IMAGES
of America

SIDNEY

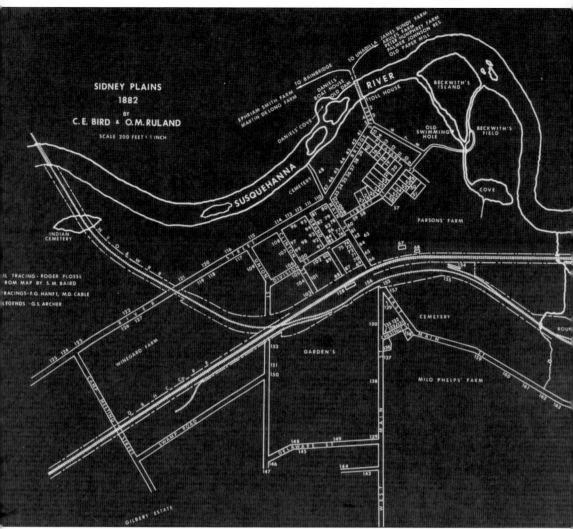

Sidney, New York, is located in Delaware County, bordering Chenango and Otsego Counties. This geographic convergence is known as the "tri-county" area. Much has changed since the town was known as Sidney Plains in 1882, and it has grown substantially. At the time of the 2000 census, the town's population was 6,109, with 4,068 living within the village. (Courtesy of the Sidney Historical Association.)

ON THE COVER: Based on Smalley Theater's marquee showing Richard Barthelmess in *Alias the Doctor*, this view of Main Street can be dated to approximately 1932. While the general layout of the buildings remains the same, much has changed over the years. Today the Smalley's Theater building is home to Emerald City Salon and Joe and Vinny's Pizzeria. (Courtesy of the Sidney Historical Association.)

IMAGES
of America

SIDNEY

Erin Andrews and the
Sidney Historical Association

ARCADIA
PUBLISHING

Copyright © 2010 by Erin Andrews and the Sidney Historical Association
ISBN 978-0-7385-7297-0

Published by Arcadia Publishing
Charleston SC, Chicago IL, Portsmouth NH, San Francisco CA

Printed in the United States of America

Library of Congress Control Number: 2009940131

For all general information contact Arcadia Publishing at:
Telephone 843-853-2070
Fax 843-853-0044
E-mail sales@arcadiapublishing.com
For customer service and orders:
Toll-Free 1-888-313-2665

Visit us on the Internet at www.arcadiapublishing.com

*To everyone who has lived in, worked in, or visited Sidney
and has a special place in their heart for our town.*

CONTENTS

ACKNOWLEDGMENTS

It is absolutely no exaggeration to say that this book would never have come to fruition without the hard work of the Sidney Historical Association's diligent volunteers. Nobody there is compensated for their work, yet everyone laboriously contributed time, effort, and expertise to this important historical project. Specifically, credit is due to Evy Avery, Graydon and Irene Ballard, Joelene Cole, Bonnie Curtis, Beverly and Les Gregory, Terry McMaster, Alfred Olsen, Mike Wood, and anyone else who attended one of our monthly book workshops to search for photographs, research our past, and write and edit captions and/or chapter introductions for *Sidney*. Thank you all so much for the hours you've put in to create the first book written on the town's collective history in almost four decades!

Sidney's sense of community shines throughout the pages of this book. Not only does it celebrate the events that brought the area to its present state, but it is yet another example of residents coming together to complete a common goal. Unless otherwise noted, all photographs are courtesy of the Sidney Historical Association—but it goes much further than that. Private photograph collectors and historians, past and present business owners, civic organizations such as the Sidney Central School Alumni Association (referred to as SCSAA), and just regular folks have contributed a great number of wonderful images to help the story of the past come back to life.

Thank you to the families, the students, the employees, and the visitors. Whether we realize it or not, everything we do—everywhere we shop, play sports, attend weddings, or go to work— becomes a part of Sidney's history. It is these daily activities and small moments that have built our community since its founding in 1772. Thank you for being a part of this book.

INTRODUCTION

Sidney's history begins long before the pages of this book, before the advent of the photograph or a time from which a substantial amount of material culture remains. The first European American community founded at what is now Sidney was begun centuries ago following the signing of the Treaty of Fort Stanwix of 1768. The treaty established a new boundary line dividing English territory to the east from Native American country to the west. This new boundary line ran down the Unadilla River, crossed the Susquehanna River, and continued south into Pennsylvania.

Rev. William Johnston descended the Susquehanna River in 1770 with a Native American guide, camping on the south side of the confluence of these two rivers. Johnston fell in love with the lush valley's wild beauty, where "deer exist by the thousands, and fish by the hundred thousand." He purchased 640 acres on the Susquehanna River in what was called "Old Unadilla" the following year from a patent holder in Albany. The next year, Reverend Johnston built a log cabin with his son Witter and began clearing the land and farming. Witter remained there over the winter in companionship with several local Native American families, and in the spring of 1772, Johnston returned from the Mohawk Valley with his family. At this time, several other families joined them, and this community became known as the Johnston Settlement. It is because of the community created when these families relocated to this area that the Johnstons have since been considered "Sidney's Founding Family."

Rev. William Johnston is known as Sidney's founding father. He was born in Dublin, Ireland, in 1713 and immigrated to America in 1744, where he married Nancy Cummins in 1748. In May 1772, the reverend, his wife Nancy, three sons, and four daughters made the river journey from Duanesburg, New York, to the property in present-day Delaware County. There was nothing comparable to the European roads that Johnston was accustomed to, and the nearest non-native neighbor was 75 miles away from this budding colonial settlement. Home to the Johnston family was the 16-by-22-foot cabin that the reverend and Witter constructed the previous year. It was located in an area known by the natives as Brant Hill, the modern-day site of the Sidney Municipal Airport. The Johnstons lived and worked there, on land near today's MeadWestvaco Corporation, until June 15, 1775, when the Iroquois leader and Tory ally Joseph Brant gave them 48 hours to leave the area or be killed. He was, after all, the man for whom the area was named and held great power and influence through his supportive and violent followers.

The Johnston Settlement families were living on the edge of what they would consider civilization, their community being the most remote outpost in the colony of New York during the early 1770s. When the Revolutionary War broke out, they were left exposed to any hostile forces that may have wanted to oppose them. In 1775, Reverend Johnston and most of the families in the area petitioned the governor for soldiers to be sent to protect them, but the settlement received no assistance. Two anxious years passed until June 1777, when they were paid a visit by the Mohawk war captain Joseph Brandt, accompanied by about a hundred warriors. At this time, Reverend Johnston spoke of peace and encouraged Brandt to remain neutral. Brandt dismissed Johnston's attempts to avoid

conflict and stated that, as he was aligned with the British cause, he would not make a treaty with the colonial settlers. Brandt demanded that the families declare allegiance to the king or leave their newly created homes. While many families relocated to Cherry Valley in the colony of New York, several of them proclaimed loyalty to the king and stayed and supported Brandt's position, and the settlement became a Tory outpost. Leaving all but a few personal possessions behind, Sidney's earliest settlers fled in two bateaus for Cherry Valley, living there with other Scottish Irish settlers until November 11, 1778, the night of the infamous Cherry Valley Massacre. With a mere 20-minute warning, Sidney's founding family managed to escape the murderous attack by Brandt, Tory colonel John Butler, and 700 native and Tory troops. Twenty-eight unfortunate settlers died in the attack. After the massacre, the Johnstons made their way to Schenectady, where they stayed until the spring of 1779.

At the conclusion of the war, it was relatively safe to resettle the Susquehanna Valley, as the Clinton-Sullivan Campaign against the Iroquois had burned the native villages, fields, and orchards, and the most hostile natives had relocated to Canada. In May 1784, the reverend's sons Colonel Witter and Capt. Hugh Johnston were safely home. At this time, the family—with the exception of Reverend Johnston and son William, who both died in 1783—began the journey back to Old Unadilla. Witter and Hugh had both earned their stripes in the militia during the war, and they, with their mother, four sisters, and a few other families, began to remake their lives and rebuild the town. They reclaimed the land, repaired fences, and constructed another cabin to replace the destroyed one. They lived there until 1798, when they built a larger frame house near what is now the corner of Route 8 and River Street. Rev. William Johnston's widow, Nancy Johnston, died in 1795. She, her sons, daughters, and their spouses are buried in the Sidney Plains Pioneer Cemetery behind the Sidney Memorial Public Library, on the banks of the Susquehanna River where the reverend first examined the territory decades before.

Originally known as Old Unadilla, then the Johnston Settlement or Susquehanna Flats, the growing village was separated from the town of Franklin in 1801. The first elected supervisor was Col. Witter Johnston, the reverend's son, who assisted him in constructing the settlement's first home. The area soon became known as Sidney Plains, which eventually was shortened to Sidney. Over the past 238 years, innumerable families have passed through Sidney, some of whom are still here today, and some of whom have descended from the Johnstons, Sidney's founding family. (Written with Evy Avery and Terry McMaster.)

One

FACES OF SIDNEY

Anyone who knows Sidney, New York, knows that its people make it special. Ever since Rev. William Johnston settled Sidney Plains in 1772, noteworthy individuals and families have been making their mark in this bucolic, yet ever-growing territory. Some of the faces may not be recognizable, but the contributions of Sidney's men and women can be seen in the town's industries and longstanding, family-owned companies. Street names such as Johnston Circle, Bird Avenue, Steiner Road, and Loomis Drive pay homage to those who have helped develop Sidney as it is known today. Furthermore, families who have been in the area for generations, like the Whitakers, Mazzarellas, and Mirabitos, came to Sidney for opportunity and, in turn, worked to create the close-knit community and strong local commerce that the village has been known for over the years.

While some families have been in the Sidney area for as long as they can remember, often with genealogical ties to England and colonial America, others were uprooted and traveled great distances to settle here. From Italy in the 19th century came men who built important railways, bringing their families with them to the downtown and Brooklyn neighborhoods of Sidney. From Switzerland in the 20th century came brilliant engineers to work in the Scintilla plant, bringing their plans for a magneto that was comparable to none and cultural traditions that were celebrated through the local Swiss Club.

Whether a lifelong resident of Sidney or someone who is reading about it from another state, the personal stories and public profiles tucked between history's pages are surely of interest. The images in this chapter were created by professionals and amateurs, providing faces to put with the names and stories that are heard and seen throughout Sidney. These faces, along with those that residents and visitors pass everyday, are what make Sidney unique.

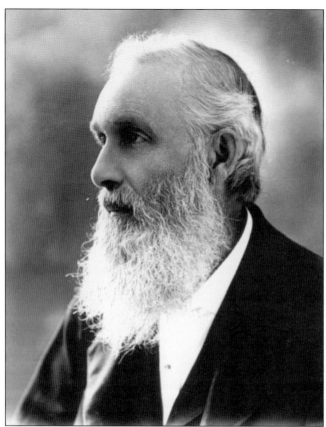

Thomas G. Smith was a dry goods and clothing store owner who also built the Hotel Irving on the present site of Rose Realty. A story is told that he once invited a young, attractive girl to supper, where his wife Sofia asked him if he wanted a fruit or vegetable supper. When he replied "a fruit supper," Mrs. Smith proceeded to serve him and the young lady each an apple!

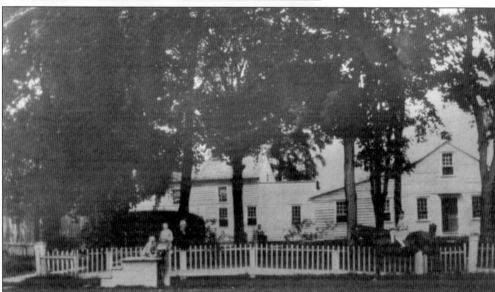

Abner Johnston, a member of Sidney's founding family, built this house. Abner lived from 1808 to 1893. From left to right are Edith Ballard, Abner Johnston, unknown, and Kitty Hill. A portion of this home is still standing on lower River Street, but it was heavily damaged in the flood of 2006. (Courtesy of Ginny Tiska.)

Willis Winegard came to Sidney in 1867 when his parents purchased a tract of land extending from River Street to the old Camp Grove. He opened a bakery in 1888 and grew strawberries in fields near present-day Winegard Street. He organized and played cornet in the Sidney Band and was called the "biggest liar in town" due to his propensity to tell tall tales.

Merville B. Cook owned and operated a meat market at 9 Smith Street for almost 40 years. For a small portion of that time he was in partnership with Egbert DeForest, then later with George Clayton. Over the four decades, however, Cook mostly conducted business on his own.

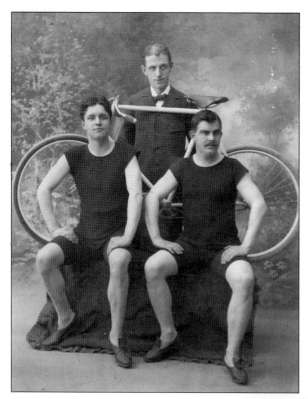

Bicycling was king of sports in 1900. There was talk of building a cinder cycling path from Binghamton to Albany. There was one between Sidney and Unadilla. Cyclists pictured are Clarence Bird, B. E. Pudney, and Fred Curtis. An 1885 public notice appeared in the *Sidney Record*—"Officer Hoose decides to inform bicycle riders that while riding through our village streets, they must not go faster than 4 miles an hour."

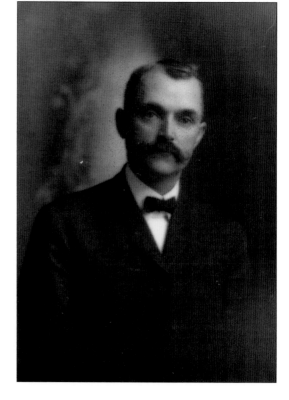

After graduating from New York University in 1888, Dr. L. M. Day began his medical practice in Burlington Flats, New York. After 10 years, he moved to Sidney and enjoyed a prosperous career as a doctor for over 40 years from his residence on Pleasant Street. He served on Sidney's chamber of commerce as well as the school board.

Bert E. Pudney was a talented businessman who first opened a bicycle shop in 1895. He was also a photographer, served as Sidney's fire chief, and was elected mayor in 1917. Pudney expanded his business to include a piano and organ store. He is best known for his photograph postcards of the area that are widely sought after today.

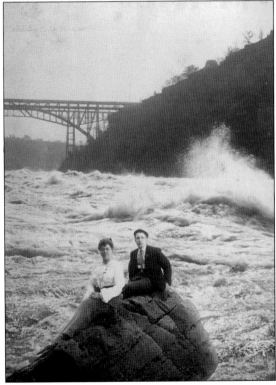

Pictured here is Nellie Schleeke with her son at an unknown location. Nellie's husband, George, was a blacksmith in Sidney whose shop was attached to their home on Bridge Street. Family folklore says Nellie had clairvoyant powers or, at the very least, the uncanny ability to find people's lost objects!

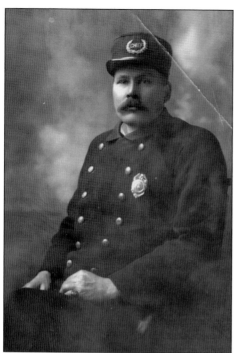

William "Reddy" Dickinson was the first salaried chief of police to patrol the streets of Sidney, helping to solve at least three murders during his career. He served as a constable, police officer, and chief of police from 1892 until 1934, at which time his son, Capt. Harry O. Dickinson, began wearing the ever-important badge of the Sidney chief of police.

Henry Warren Clark was president of Sidney Water Works from 1889 to 1916. At first, water was pumped to Main Street from artesian wells on Prospect Hill, producing four barrels an hour. Demand increased, and Sidney began to build reservoirs. Eventually, people south of the railroad tracks were piped water from the Pine Hill Reservoirs and people north of the tracks were supplied with water from Trestle Reservoir.

As transportation technology changed, Mr. L. I. Hatfield ventured to manufacture the Hatfield automobile at the Cortland Cart and Carriage Company. He conducted this business from 1915 to approximately 1924, when his buildings were sold to Scintilla Magneto Company. Hatfield's residence still stands at 62 River Street and looks exactly like it did when he lived there.

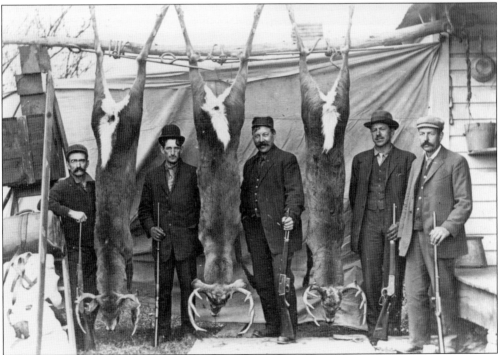

Will Winegard, Fred Race, George Schleecke, unknown, and William Rifenbark proudly show off their hunting prowess. Sidney and the surrounding area once hosted thriving wildlife such as moose, bobcat, deer, coyotes, and turkeys. In the days of these men, hunting was a means of putting food on the table for their families.

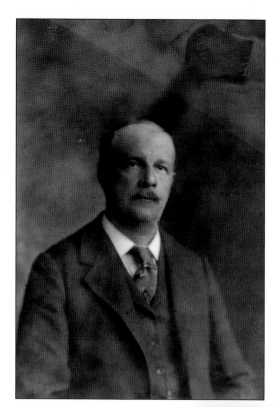

Arthur Bird was well equipped to edit and publish his successful newspaper, the *Sidney Record*, from December 7, 1882, until his death in 1935. He strongly supported the growth of Sidney. He had a keen sense of individual values and instinctively put his finger on the right and wrong of public problems. Sidney's Bird Avenue is named for him.

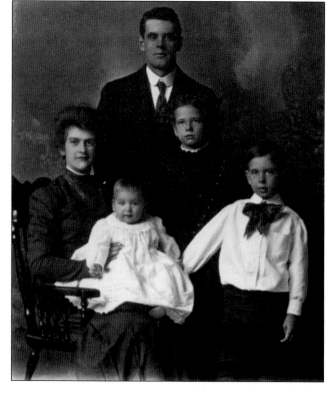

The Frank Howe family is shown here from top to bottom: Frank (in rear), Effie (left) and Grace, Millard on Effie's lap, and George. Frank opened a bicycle repair shop on Cartwright Avenue in 1896. As years passed, along with the advent of the automobile, Howe expanded his business by building a garage on Smith Street.

Jay Williams became the proprietor of the Hotel Sidney in April 1901. With his arrival, renovations and improvements to the hotel included the installation of electric call bells, the purchase of new furnishings, and the building's first lavatory. In addition, new floors were installed in the office, barroom, and the billiard room.

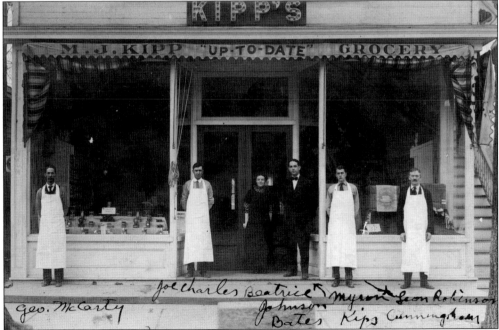

Myron Kipp began his successful grocery business in 1904 and operated from the same location on Main Street for over 50 years. He dedicated time to serve on the Sidney Chamber of Commerce, school board, and even as postmaster. This photograph of his store shows, from left to right, George McCarty, Joe Charles, Beatrice Johnson Bates, Myron Kipp, and Leon Robinson Cunningham.

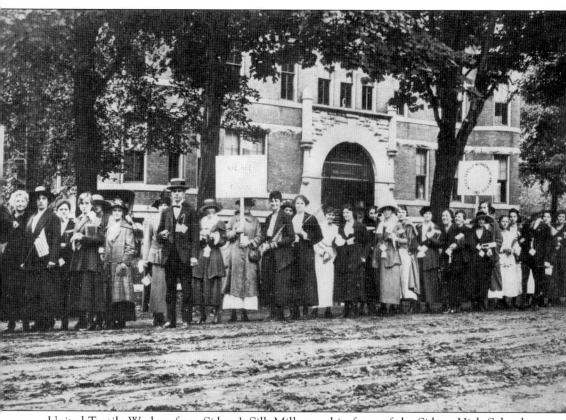

United Textile Workers from Sidney's Silk Mills stand in front of the Sidney High School on Pleasant Street with a sign dated 1903. Sidney's Clark Silk Mill began in 1892 and ran until 1907 when Julius Kayser purchased the business. Expansion included a larger building on the Susquehanna River.

Riley Heath graduated from Sidney High School in 1907. Raised by a wise and prudent mother who stressed the importance of an education, he graduated from Cornell Law School in 1912. Heath went on to serve as a New York State Supreme Court justice from 1931 to 1943 and again from 1949 to 1951.

Robert Eugene Carr, a former manager of the "Beehive Stores," purchased the furniture and undertaking business from Mr. L. L. Heath in July 1906. He was a graduate of Hartwick Seminary, a member of the state board of undertakers, Knights of Pythias Lodge No. 255, Sidney Lodge F&AM No. 801, Sidney Grange, and the Sidney Chamber of Commerce. His funeral home was located on River Street.

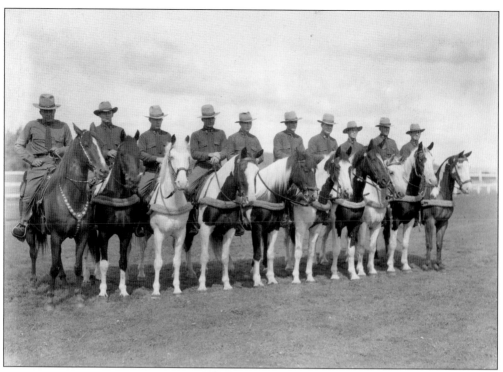

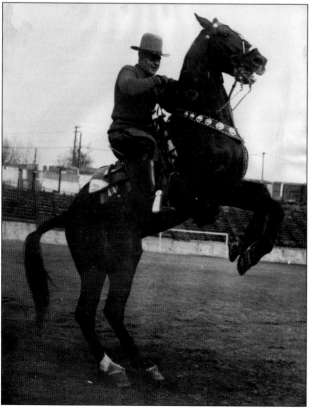

The above photograph shows the New York State Troopers from Troop C "Rough Riders." From left to right are Capt. Daniel Fox, C. Compton, Bill Packard, Bill Waldron, N. Hoskins, Whitey Shephard, Russ McClenon, Gene Palombo, Guy Moore, and Bob Flynn. Captain Fox, the first commander of Sidney's Troop C, led the Rough Riders in the 1920s and 1930s. This group of trick riders was famous for their superb horsemanship and performed annually at Madison Square Garden in New York City. They were invited to perform in London, but could not take time for the trip. At left is Capt. Daniel Fox on his trick riding horse.

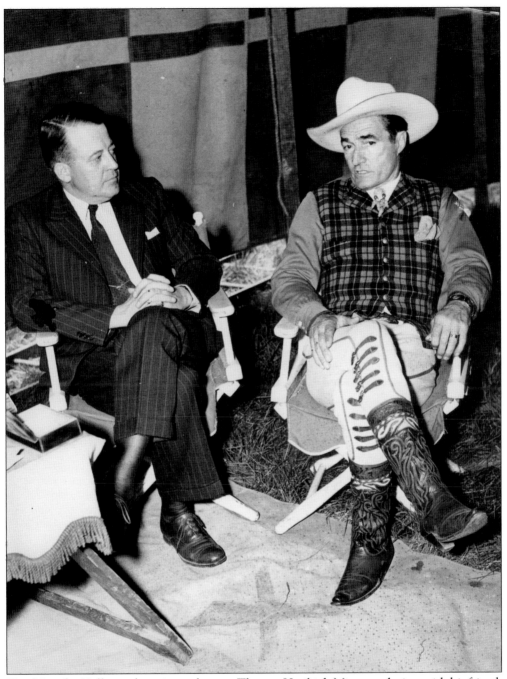

Tom Mix, the Hollywood movie star born as Thomas Hezikiah Mix, spends time with his friend, Capt. Daniel Fox, while visiting Sidney. Troop C captain Daniel Fox often entertained famous people in the 1920s and 1930s such as Jimmy Braddock, Clyde Beatty, and Max Schmeling at his home on Bridge Street.

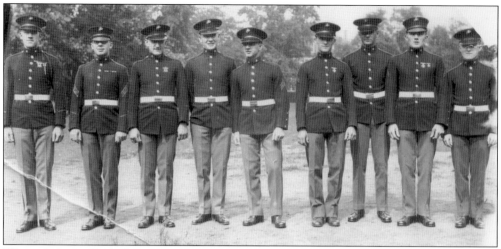

Ellwyn G. Rowe (far left) was a gunnery sergeant in the U.S. Marine Corps during World War I. He wore the Croix de Guerre with bronze star, awarded by the French government for conspicuous gallantry, and was selected as one of the 24 men from the three fighting arms of the military to form the guard of honor and escort the body of Pres. Woodrow Wilson to his final resting place. (Courtesy of John Rowe.)

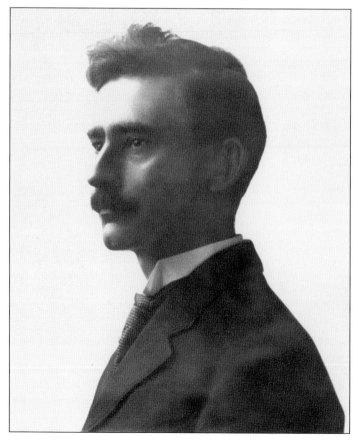

Winfield Sherwood was determined to locate new sources of capital for Sidney after the Hatfield automobile factory closed. He arranged for the Brown Boveri Company of Switzerland to visit in 1924. They found the perfect opportunity to establish an American branch in Sidney. Although Sherwood did not live to see the Scintilla Magneto Corporation, it became Sidney's most profitable business. Sherwood Heights housing development was named in his honor.

On February 26, 1896, Evans Fordyce Carlson was born in the parsonage of the Congregational church. His father was the minister. Carlson became famous during World War II as commander of Carlson's Raiders. This marine unit was known for courageous action behind enemy lines in the Pacific Islands. Brig. Gen. Carlson died May 27, 1947. He was buried in Arlington National Cemetery. (Courtesy of the National Archives.)

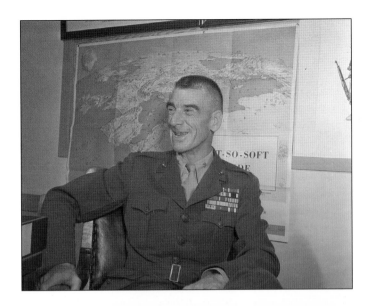

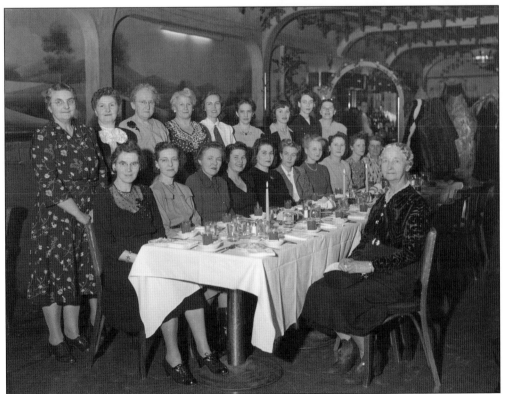

Pictured are the women of Sidney's Swiss Club at the Green Garden restaurant (today's Community Lounge) in 1948. From left to right are (first row) Rose Herzog, Catherine Keller, Margot Walton, Helen Kappeler, Marion Fust, Margarethe Kleiner, Dora Hauri, Margaretha Tognola, Frances Zurbrugg, and Henrietta Loetscher; (second row) Helen Hediger, Marie Bernhard, Mary Mugglin, Emma Weilenman, Frances Burki, Antonette Preisig, Rina Taeschler, Audrey Winkler, and Madeleine Egli. On the other side of the table is Bertha Meyer.

George E. Steiner, the first general manager of Scintilla Magneto Division of the Bendix Corporation, was Sidney's "Man of the Years" in 1950. Steiner's background of service and keen appreciation of future needs was a vital asset to Scintilla and Sidney. The village named Steiner Road, which runs by the Sidney Plaza, in his honor.

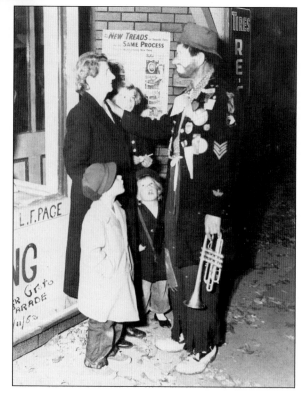

Here is Lee Laraway, a member of the Sidney Masons, dressed as a clown for a Zor Grotto celebration in 1952. The Zor Grotto was a local Masonic organization that was formed in Sidney on August 23, 1944. The first class of petitioners for membership included 200 or more charter members.

24

This photograph shows some notable Sidney residents at Lucille Spengler's wedding reception. Lucille's father, Walter, was director of engineering at the Scintilla factory. Pictured from left to right are Berton Fairbanks (Fairbanks Pharmacy), Tony and Sophia Weiss, Dr. Ralph Loomis, Lucille Spengler, Mary Yenson, Herb Walters, unknown, Marie Hanni, and Fannie Loomis.

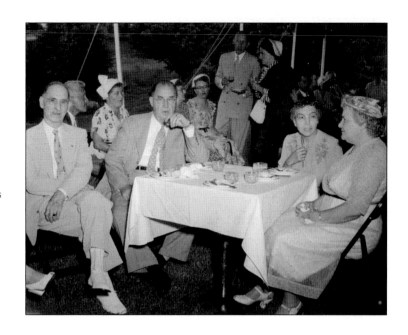

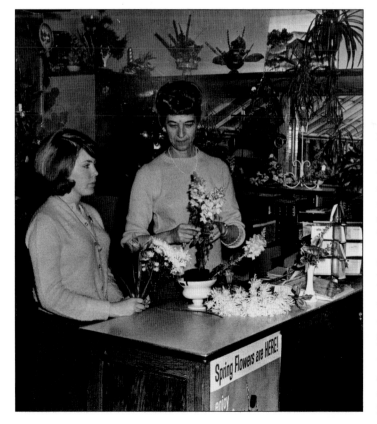

A study of Sidney businesses and their operational procedures was conducted in cooperation with the Sidney High School during the early 1960s. Cynthia Gleason (left), a high school student, talks flowers with florist Martha Wade, owner of Wade's Greenhouse located on Riverside. Students sometimes shadowed business owners to learn good business ethics and to gain the experience of being part of the workforce.

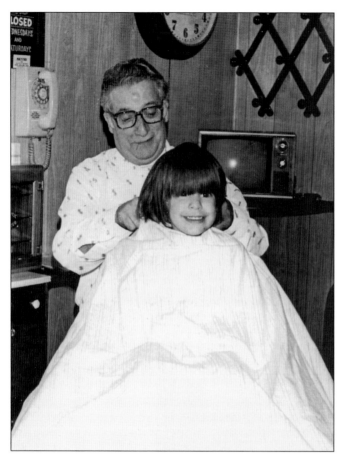

When men and boys found it was time for a haircut, many gravitated to Sam's Barber Shop, owned by Sam Provenzon on Smith Street, to get their locks shorn. While waiting their turn, it was a natural thing to swap stories and get an earful of town happenings at the same time. Provenzon is shown here cutting a young man's hair, perhaps in time for the opening of school. (Courtesy of Joe Provenzon.)

Joseph Wade affixes a metal plate advertising Sidney, Unadilla, and Bainbridge as covered-bridge towns as Frank Turk and Grace Terwilliger (who designed the plates) look on. Selling these plates was for a fund to move a historic covered bridge to a site within Sidney's town limits. Unadilla's covered bridge was over Ouleout Creek, and Sidney's spanned the Susquehanna River at Bridge Street.

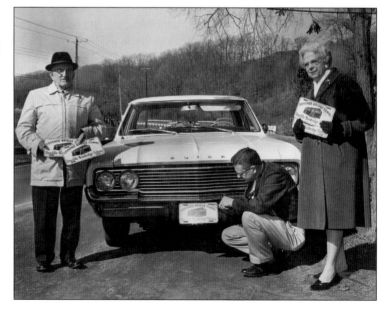

Two

Main Street and Businesses

Throughout Sidney's lifetime, many businesses have lined its main and side streets. Larger industries have also been an important economic strength and source of employment. Some local businesses and industries did not last too long, but others flourished through generations and even centuries. Grocery stores, men's and women's shops, restaurants, hotels, movie theaters, dairies, and other small, locally owned businesses once filled the streets with anxious and excited customers. The types of commerce seen in downtown Sidney may have shifted from these mom-and-pop stores to convenience stores and national chains, but the village remains an important site that draws shoppers from the surrounding towns to its central tri-county location at the corners of Delaware, Chenango, and Otsego Counties. Industries producing calendar products and electrical components have been and continue to be the largest sources of work in Sidney, although these local sectors are downsizing in favor of international labor sources.

As times change, inevitably, so does the small town. Businesses, for one reason or another, are forced to close their doors either temporarily or for good. New owners sometimes renovate spaces to suit current needs, such as the Verizon store on Main Street, whose building has housed a gift shop, tattoo parlor, bike shop, bookstore, and several other businesses within the last 20 years. In the past year, Sidney has had to say goodbye to two of its oldest businesses in the name of change—Fairbanks Pharmacy and Whitaker and Son, Inc. car sales, which began in 1866 and 1912, respectively. The two companies have been replaced by a brand-new Rite Aid pharmacy, which stands on the site of Whitaker's car lot and serves the public that once looked to Fairbanks for prescriptions and gift shopping. While it has been sad to see these historical businesses shut down, the construction of a state-of-the-art pharmacy is just the newest example of how Sidney has always taken strides to expand its commerce and better serve not only its own residents, but also those who have looked to Sidney as a reliable source for those must-have items.

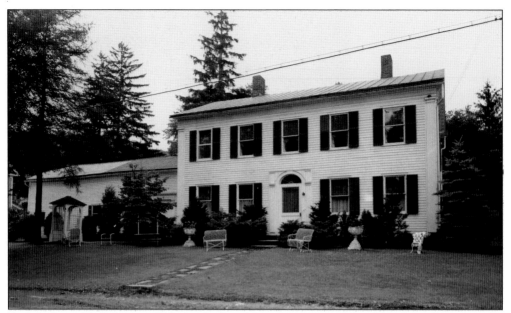

Built by James DeCalvin in 1795, the Andrew Mann Inn is one of the oldest frame houses in the area. Over its 215-year history, the property has been a private residence, an inn on the Catskill Turnpike, a large farm, and even home to a local horse-breeding venture and racing track. Placed on the National Register of Historic Places in the late 1970s, the house is now abandoned. (Courtesy of Evy Avery.)

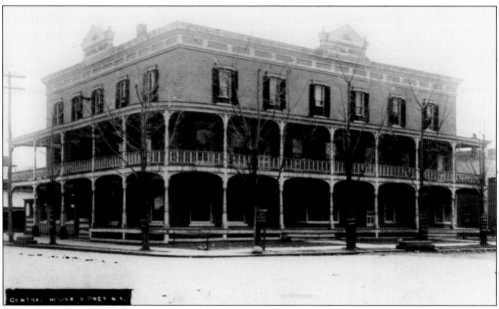

Judge Rexford built the house that became the Central House near the corner of Main and River Streets in the 1830s. Samuel Cumber purchased it in 1883, adding a three-story brick structure in 1891. By 1917, it was a boardinghouse and site of Whitaker's automobile showroom. Later it was the temporary headquarters of Troop C state troopers. The building was demolished in 1937. (Courtesy of Evy Avery.)

H. C. Weller established the building at the corner of Liberty and Main Streets as a pharmacy in 1866. Burton Fairbanks, a clerk there since 1901, received his pharmacist license in 1905, buying the business in 1911. Fairbanks retired in 1955, when the VanValkenburg family took over. It was one of three businesses operating since the 19th century, closing in July 2009 when Rite Aid opened across the street.

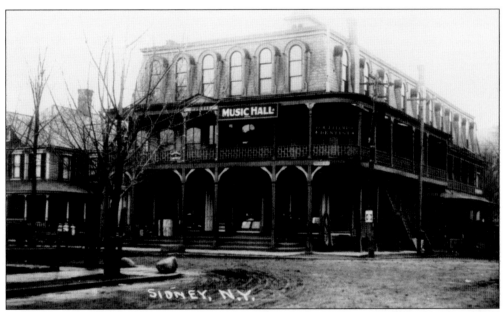

Constructed in 1866 on the site of the current library, the Hodgson Building, or Music Hall Block, was then considered the largest wooden structure between Binghamton and Albany. Over the years, its third floor was used for Regents exams, graduations, dances, and concerts. The lower two floors housed various businesses: a furniture/undertaker establishment, dentist, musical instrument dealer, and restaurant. It was demolished around 1934, when Main Street was extended to the new bridge.

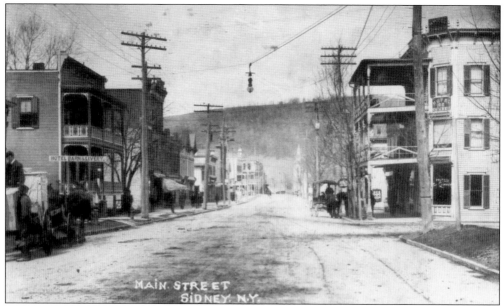

James T. Beal purchased the Mitchell property in 1882. Located on Main Street where the old bank building now stands, the house and two other properties burned shortly thereafter. Beal immediately rebuilt it, opening the Mitchell House in late 1883. In 1913, it closed as a hotel, and the structure was moved to the Grand Street side of the lot, where it became a tenement house. (Courtesy of Evy Avery.)

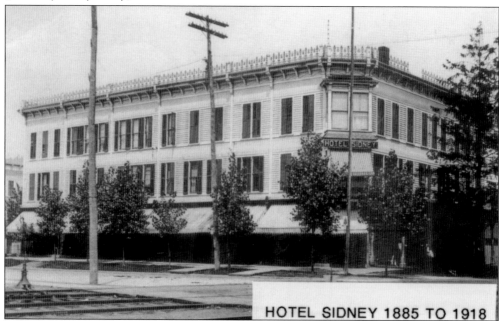

HOTEL SIDNEY 1885 TO 1918

Shortly after Mr. Cartwright purchased the old Parsons property, it became evident that its northwest corner, fronting Main Street and facing the depot, offered unrivalled advantages for hotel purposes. The Sidney House (later known as Hotel Sidney) was constructed to guarantee the traveling public the maximum of ease, comfort, and luxury. The doors of the palatial hotel were thrown open to the public Thursday evening, August 27, 1885.

30

Sidney's first bank, the Sidney National Bank, opened December 29, 1887, in the Hotel Sidney block and can be seen here. A second bank, the People's National Bank of Sidney, began 20 years later. The two merged, purchased a lot on Main Street, and constructed a fireproof building, opening November 28, 1914, as the First National Bank of Sidney. (Courtesy of Graydon Ballard.)

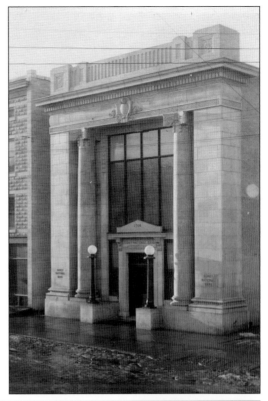

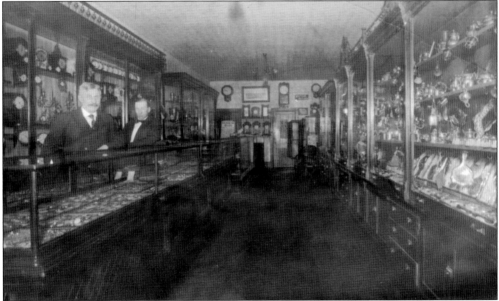

The oldest existing jewelry and optical business in New York State is George W. Cooley and Son of Sidney. It moved from Morris in 1888 after George W. Cooley's father established it in Cooperstown. In 1904, George's son Henry joined the business. His sons George II and Richard S. began work in the 1940s. George II's son Richard W. is currently the sixth generation owner, working in the same building at 77 Main Street. (Courtesy of Evy Avery.)

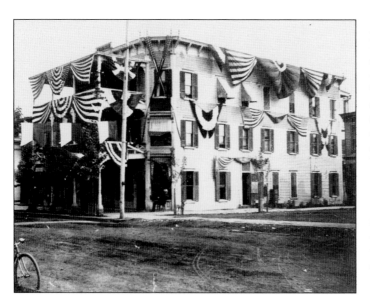

Samuel Cumber built the DeCumber in 1894–1895 on Main Street between Smith Street and Cartwright Avenue. The original structure was added to over the years, extending down both side streets. William Turk bought the DeCumber in 1908, operating it until 1942. Closing as a hotel in the 1960s, it served as a bar and restaurant. Surviving arson in 1990, the building today houses several small businesses. (Courtesy of Evy Avery.)

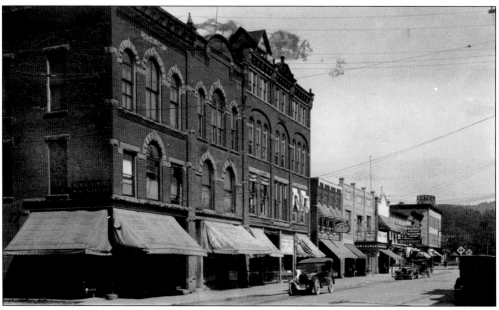

Businessman A. D. Smith built the Hotel Irving in the Bennett Block in 1895. There were 12 "sleeping rooms," a dining room, office, billiard room, and store. A large cupola on the roof held a bell to be rung in the event of a fire in the village, and ironically a 1968 fire resulted in the removal of the top story. (Courtesy of Evy Avery.)

In the 1890s, Sidney's population was only 2,600, but there were seven hotels. The Wyandotte Hotel was built on Cartwright Avenue, because many bachelors employed at the Sidney Glass Works needed places to stay. This hotel was also known as Davis House, Delaware House, Hotel Booth, Hotel Torino, and finally Cartwright Hotel. In September 1968, the Cartwright Hotel burned to the ground, claiming two lives.

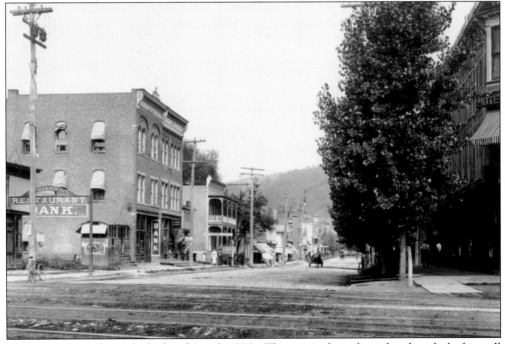

This is how Main Street looked in the early 1900s. The view is from the railroad tracks looking all the way down the street toward Mount Moses and the Susquehanna River. Hotel Sidney can be seen on the right and Sidney National Bank on the left. Note the small diner next to the bank.

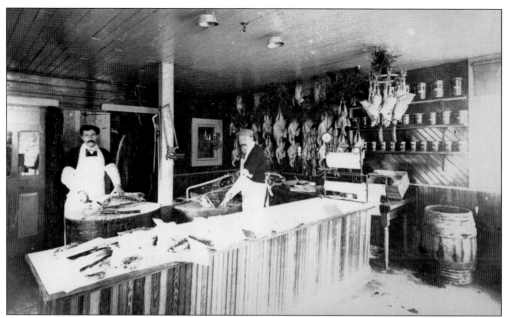

George Clayton and Merville Cook purchased E. R. DeForest's Main Street meat market business on May 6, 1905. A large tank in front of their store guaranteed fresh fish weekly. The store was known for having fresh vegetables and the best grade meats on hand. Merville Cook originally operated the business with DeForest, then Clayton, and finally became sole proprietor for over 39 years, moving to 9 Smith Street.

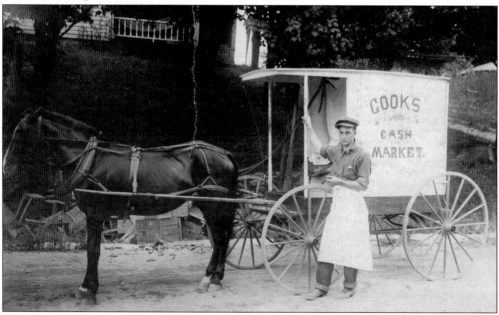

Cook's Cash Market's carriage was used for delivery purposes and transporting merchandise to the store. The establishment was well known for having a fine selection of pure teas, fragrant coffees, relishes, sauces, condiments, choice flour, laundry supplies, syrups, select dairy and creamery butter, fresh eggs, and domestic fruits. The cost of five pounds of sugar was 25¢, the same price as one pound of butter.

Sidney Favorite Printing opened in 1897 on River Street and is one of only two businesses still operational in Sidney since the 19th century. A separate building was erected in 1920 and expanded around 1975. Lynn Earl bought the business in 1946 from Elsie Waters. His son Tom ran it until 1985, selling it to Paul Hamilton and Ken Paden. Its current location is in the Sidney Industrial Park. (Courtesy of Evy Avery.)

The Central New York Telephone Company, part of the Bell Telephone Company, ran a telephone line to Sidney Plains via Bennettsville and Bainbridge on September 11, 1884. This line connected to the Oneonta-Albany line. Sidney's local telephone company was called the Union Telephone Company and moved to a larger facility on Division Street on October 28, 1899. This photograph is c. 1916.

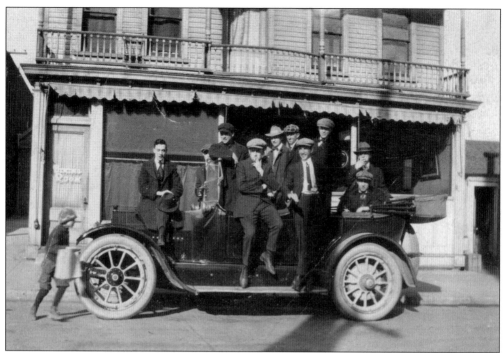

Whitaker and Son, Inc. was started in 1912 by George Whitaker and his son Glen S. Whitaker. George operated a livery stable in Unadilla, so the transition from horse and buggy to automobile was natural. Glen's son Glen E. Whitaker joined the team in 1946, and the fourth generation of Whitakers was completed with the addition of "Whit" in 1984. It was unusual for a family automobile agency to have remained in business for so many years. Whitaker's Showroom was located at 20 Main Street. Whitakers purchased the former Silk Mill by the Susquehanna River in 1946 to house their service and parts departments. A massive fire destroyed this building on August 31, 2007. This fire, combined with the flood of 2006 and Whit's being close to retirement age, contributed to the decision to close the business in December 2007. (Above photograph courtesy of Bonnie Curtis; below courtesy of Whit Whitaker.)

Kent's five-and-ten store first opened in 1931, providing shoppers with a wide assortment of items from sewing accessories to stationery, candy, toys, and more. William Kent Sr. was the first owner, with William Jr. and grandson Gary continuing business until December 17, 2003. Young patrons eagerly awaited each Christmas season for Kent's to open its basement section, which was filled with nothing but toys. (Courtesy of Louise Kent.)

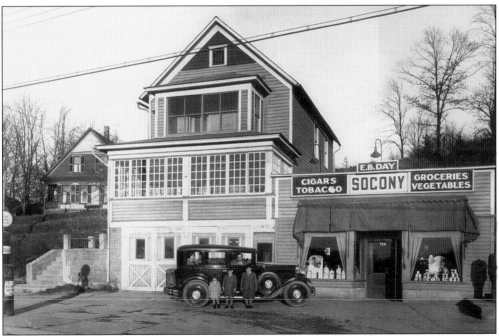

Murray and Delphine Logan started the Arrowhead Grocery in 1935, located on West Main Street on the other side of Panaro's Restaurant and previously owned by E. B. Day. The Logans soon bought the restaurant to make room for an apartment and later to expand the store. Family-run for 67 years, it was known for its homemade salads, baked beans, and friendly service. It closed in 2002. (Courtesy of Bonnie Curtis.)

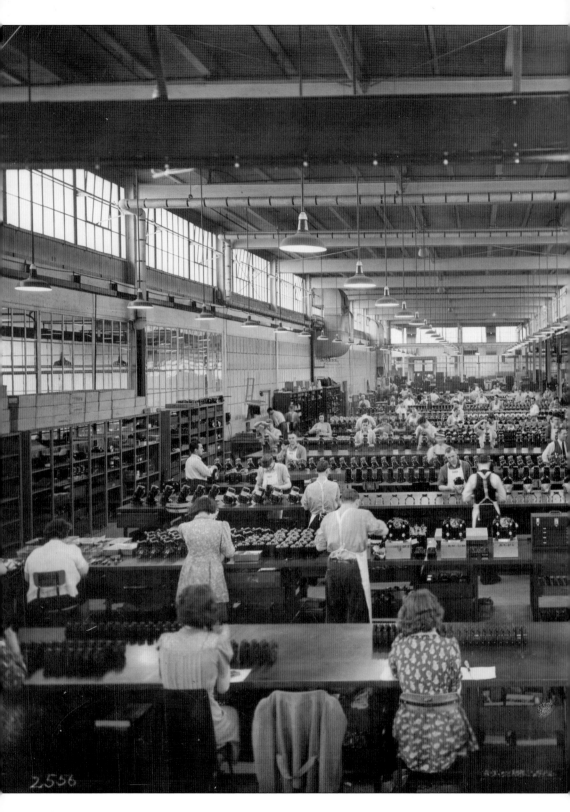

2556

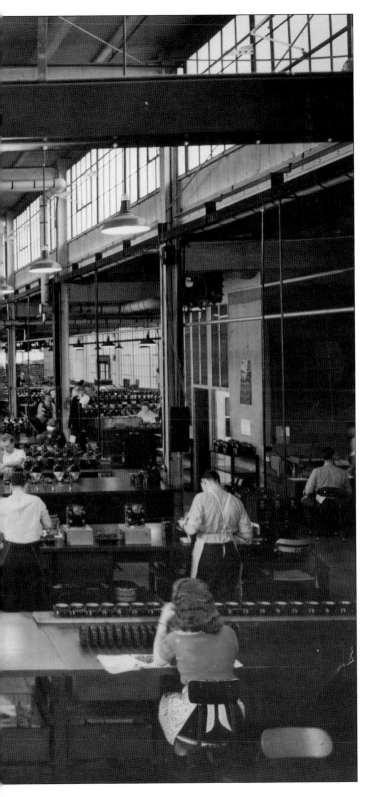

Scintilla first opened its doors in 1925 in the old Hatfield building with 15 employees. During World War I, Swiss engineers developed an innovative aircraft ignition known as the Scintilla Magneto, which Winfield Sherwood brought to Sidney from New York City. The U.S. Navy insisted that America secure its own source of manufacturing these high-performing ignition systems, rather than having a sales agency and small assembly plant, which was the case for Scintilla in the city. In 1929, the company became a division of the Bendix Aviation Corporation. By World War II, Scintilla was at its peak production, employing almost 9,000 people in a town of 6,000. Most American battle planes were equipped with ignition systems manufactured in Sidney. In the 1950s, as technologies changed, Scintilla shifted primary concentration from magnetos to electrical connectors, eventually changing its name to the Bendix Electrical Components Division.

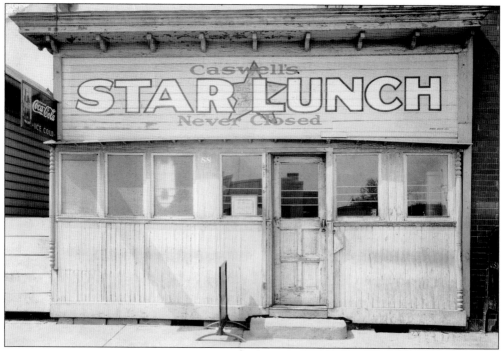

From the *Sidney Record Enterprise* of April 21, 1917, "Robert Dyckman is now proprietor of the busy Star Lunch room next to the Peoples National Bank, having purchased the interest of Mr. Louis Tuller. The place is very well patronized, with very good and prompt service, open at all hours of the day, every day in the week, every week in the year. It is a busy little spot and Mr. Dyckman will keep it right in line." (Courtesy of Bonnie Curtis.)

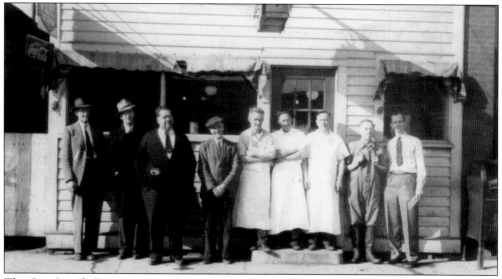

The Star Lunch Restaurant was located on Main Street and operated for over 50 years until it became Reed's Diner in 1959. In its early days, it was open 24 hours, so there were no locks on the doors. Pictured on this postcard are, from left to right, Sidney Gage, Larry Sisson, Lew Choate, Bill Brooks, Mr. Nelson, Floyd Aitken, Ralph Caswell, H. J. Spencer, and Robert Laraway. (Courtesy of Graydon Ballard.)

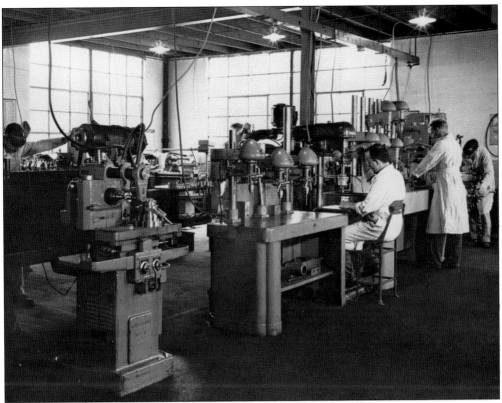

A letter to Albert Egli Sr. from his youngest son Henry, written in late 1944, triggered the founding of the Egli Machine Company. At the time, Henry was in Belgium fighting in World War II. The letter contained the statement that it would be nice to return home and work in a quiet machine shop. Egli Sr. took the letter literally and began renovating the Egli barn on Riverside in 1945. At the conclusion of the war, equipment was inexpensive, but demand for manufactured tools was low. Late in 1946, the company began to look for contract work. Some of the first projects were blanking and drawing dies. In 1949, Egli Machine began to design and build experimental molds and machined parts for Scintilla. The company is still run by family members today. (Courtesy of Henry Egli.)

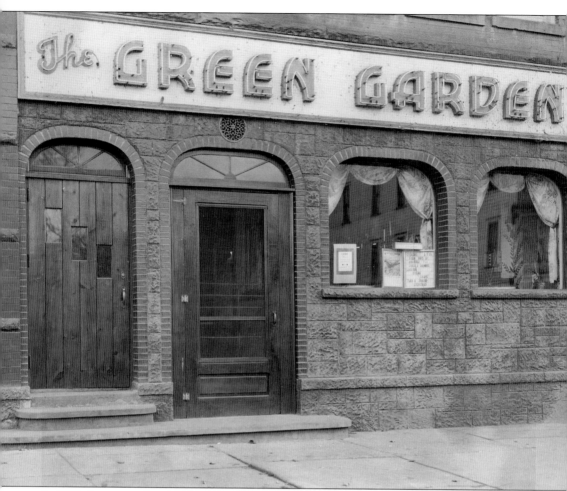

In 1937, there was a bowling league in the Lennox Bowling Alley located in the Green Garden building on Main Street. According to a 1947 phone directory advertisement, Green Garden Restaurant and Grill had the finest of foods, all legal beverages, and dancing on Fridays and Saturdays. By 1961, Horton Harvey was the owner and the name had been changed to the Community Lounge and Restaurant.

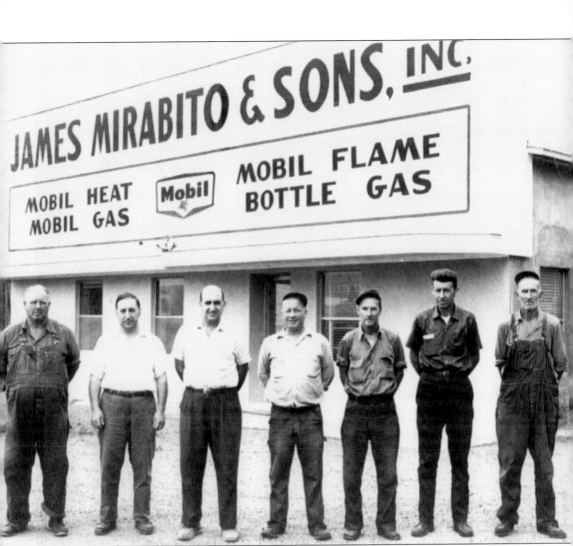

James Mirabito Sr. had great foresight in establishing a feed and coal business in Sidney in 1941. His sons Tom and Rosario (Soddy) took over ownership in 1952, running the business from their store on Clinton Street. Pictured are Clarence Hall, Tom Mirabito, Soddy Mirabito, Bernie Spencer, Roy Hall, Arnie Zurbruegg, and Ray Reynolds. (Courtesy of Mr. and Mrs. Tom Mirabito Sr.)

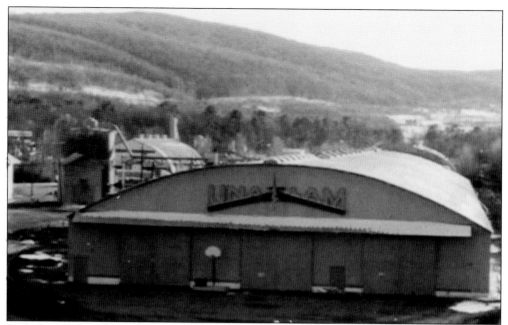

In June 1962, Unadilla Silo constructed a new manufacturing building on West Road near the Delaware and Hudson Railroad tracks where they made laminated rafters, arches, and other building products for churches, schools, and industrial buildings. This new division is known as Unadilla Laminated Products, or Una-Lam. Una-Lam enlarged its plant four times in five years.

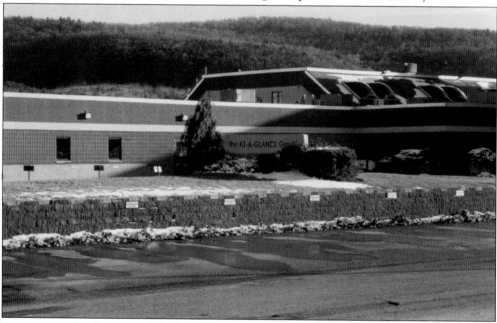

A young man by the name of Keith Clark started producing "Work-A-Day" calendars in 1923 in New York City. Production and sales were high, and expansion was soon needed. Clark purchased land on Union and Division Streets in Sidney in 1947 and further expansions called for a new building near the airport to be erected in 1969. Keith Clark Inc. became At-A-Glance and was eventually purchased by present-day MeadWestvaco. (Courtesy of SCSAA.)

Three

SIDNEY'S FORGOTTEN BUSINESSES

Is it common knowledge that Sidney once had its own cigar factory? How about a French cheese factory right in the village? Over Sidney's 238 years, a great variety of businesses and industries have enjoyed economic success. As times change, however, so do the needs of local citizens. In many cases, there are only slight reminders of the companies that were once in operation. It could be an original building that has found other uses, photographs located in the Sidney Historical Association or private collections, or the stories shared by those who remember the past. This chapter celebrates many of Sidney's "forgotten" businesses, those that even local residents may not realize ever existed in the small community.

The April 7, 1894, edition of the *Sidney Record* reported the business transacted in the village with a population of 2,400—less than half of what it is today. There were "10 Grocery Supply Stores, 8 Boot & Shoe, 3 Markets, 3 Drug, 3 Clothing-gents furnishing, 2 Merchant Tailors, 2 Jewelers-watchmakers, 2 Blacksmiths, 5 Hotels, 2 Photographers, 3 Newspapers, 2 Hardware, 2 Bakeries, 3 Coal Dealers, 2 Harness Shops, 2 Stationery, 2 Wallpaper, 3 Liveries, 4 Shoe, 2 Cigar Factories, 3 Milliners, 2 Dentists, 5 Dry Goods & 1 each of a Market Garden, National Bank, Silk Mill, Sash-Blind & Furniture Co., Toll Bridge, Glass Factory, Creamery, Novelty Works Co., Steam Saw Mill, Candy Factory, Steam Laundry, Carriage Emporium, Paper Mill, Marble Works, Wagon Shop, Soda Water, Water Company, & Oil Works." *Sidney Record* also lists five insurance agents, three real estate dealers, four lawyers, five ministers, and four physicians.

Driving through town today, it is difficult to imagine how busy Sidney once was. Of all of the local businesses listed 105 years ago, there is only one—Geo. W. Cooley and Son jewelers—that survives today. Others relocated or simply closed down for various reasons. With the advent of shopping malls and chain stores, people spend less time patronizing smaller businesses, and foreign labor continues to threaten the remaining industries. New businesses continue to choose Sidney for their home, however, and economic successes persist.

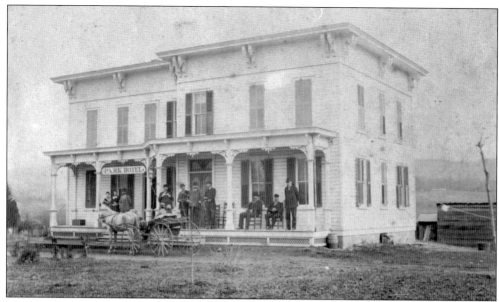

Charles Ives constructed this building next to the Old Fairgrounds in 1884. As the Park Hotel, it had a reputation for being morally offensive. Floyd Tiffany was murdered there in 1906. When Milton C. Johnston owned the house, three families lived on the second floor. In February 1913, a fire of unknown origin destroyed the place, but all eight occupants escaped safely.

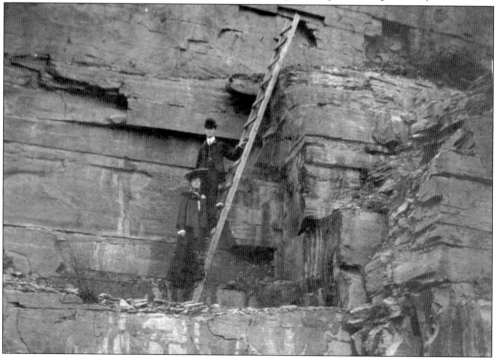

The natural bluestone quarry on Mount Moses, owned by Mort Secor, was leased to the Kelly Brothers of East Guilford in November 1886. Large quarried stone slabs were used as sidewalks in the village, and a large amount of bluestone was crushed for the construction of the state highway and local street improvement.

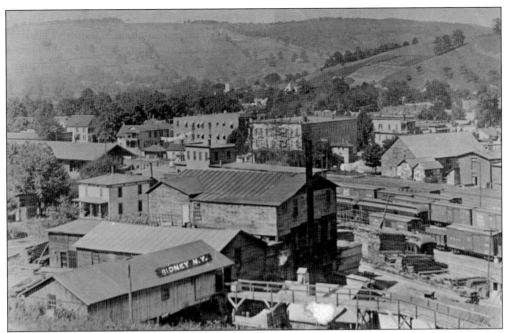

H. B. Bundy established the Sidney Mill and Lumber Company in 1888. The mill and yards were located at the end of Mill Street, today's Knapp Street. The mill produced all sorts of building material for houses such as shingles, sashes, doors, flooring, and lumber. Each year from 1888 until 1912, the business kept expanding and adding new products. (Courtesy of Graydon Ballard.)

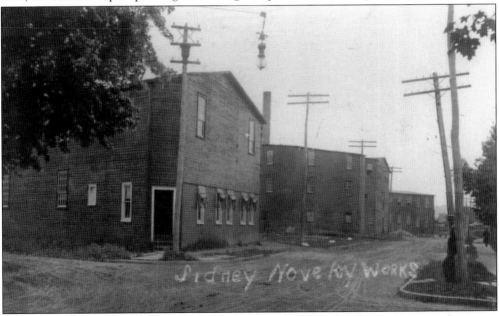

Although there were other small businesses, it is generally agreed that Sidney's first industry was the Sidney Novelty Works. It started in the spring of 1890, and at one time as many as 160 people found employment turning out a variety of articles including swings, wheelbarrows, window screens, folding chairs, and more. On Saturday, May 25, 1918, the Novelty Works was destroyed in one of Sidney's most destructive fires.

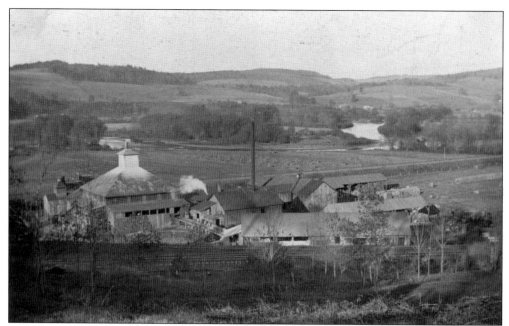

Sidney Glass Works started operation on September 23, 1891, when the first glass bottle manufactured in Sidney was presented to Mrs. Walter K. Burrows, wife of the manager. In November 1892, the Sidney Glass Works employed 100 people with a payroll of $3,500 per month. In mid-summer, the Glass Works had to shut down for a few weeks, as the heat near the furnaces was intolerable.

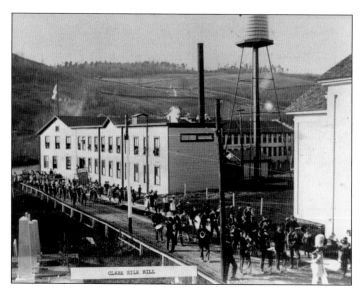

The Clark Silk Mill ran from 1892 until 1907 when Julius Kayser of Brooklyn purchased the buildings for $25,000. After a yearlong strike in 1919, followed by an earthquake in Japan that decimated the silkworm industry, the Sidney Silk Mill closed in 1927. The Schohanna Silk Mill Inc. of Greene opened in 1933. It employed over 200 people, but closed in 1935 as fashionable women stopped wearing gloves.

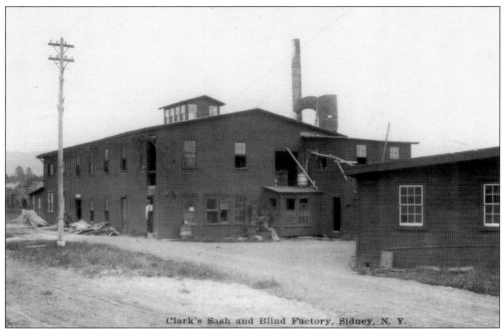

Clark's Sash and Blind Factory, Sidney, N. Y.

Built in 1893 by Martin Siver, the three-story building of the Sidney Sash, Blind and Furniture Company contained 30,000 square feet. It boasted the most modern innovations of the time, including 660 automatic water sprinklers serviced by the village waterworks, backed up by a 10,000-gallon water tower. Over $30,000 was invested, but financial trouble led to bankruptcy in the spring of 1894, and the Cortland Cart and Carriage Company took over the buildings. The partnership of Meiner and Clark bought the company's machinery in 1895 along with the stock of the Sidney Lumber Company installed in a new building on Union Street. Clark bought out his partner in 1900, and by 1913 business flourished. Regular shipments were made as far away as Argentina. What remains of this building is visible beyond Amphenol's east gate, bordering the railroad tracks. (Courtesy of Graydon Ballard.)

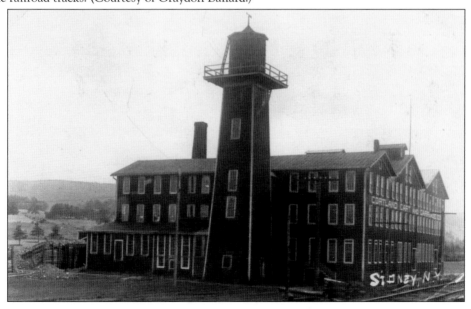

When fire destroyed the Cortland Cart and Carriage Company, the owners did not rebuild in Cortland, New York. Louis Hatfield, president of the company, chose to relocate to Sidney in 1895. This business built buckboard wagons, carriages, buggies, surreys, cutters, and sleighs. Known for the quality of workmanship, these vehicles were sold throughout the United States for 20 years.

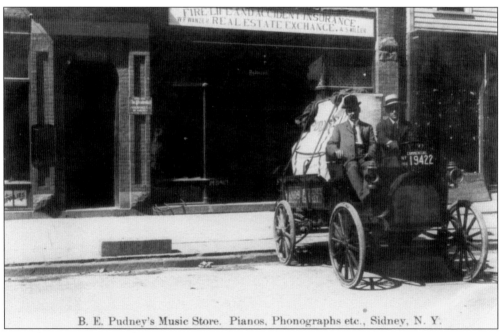

B. E. Pudney's Music Store. Pianos, Phonographs etc., Sidney, N. Y.

On February 1, 1895, B. E. Pudney opened a store specializing in selling Victor bicycles, the acme of perfection in the bicycle line. Besides bicycles, he also sold bike accessories, tools and supplies, gentlemen's furnishings, and shoes. Eventually Pudney's became a center of literature by selling books, fine art, and stationery. He expanded his business in 1901 by selling pianos, sheet music, Sidney postcards, phonographs, and records. (Courtesy of Graydon Ballard.)

50

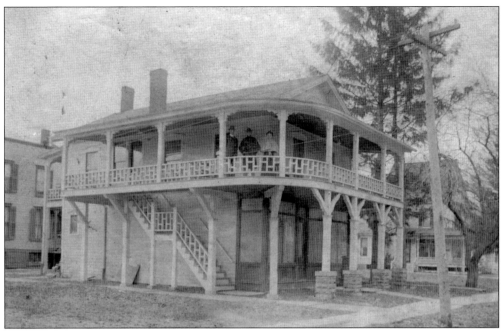

Philip Brady, a cigar maker, came to Sidney in 1895 and opened a factory in a block at the corner of River and Grand Streets. He offered a prize of 100 choice cigars for the best names for his line. From submitted suggestions, he chose the names "White Cloud" and "Tickle." In six years, Brady's Cigar Factory manufactured over 2.5 million cigars in Sidney.

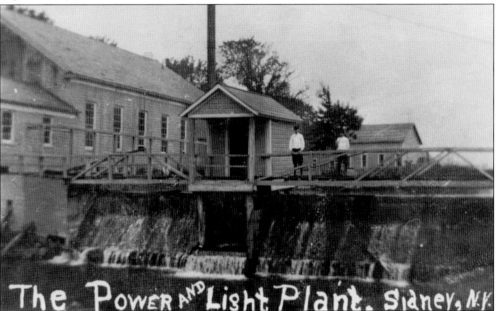

Pictured here is Sidney's Standard Light Heat and Power Company. The town's electric light system began fully operating on January 21, 1899. The power plant was erected on November 19, 1898, on the Susquehanna River upstream from the village on the site of the old paper mill. In town, electric light poles stood 125 feet apart, with lights suspended from iron arms projecting 16 feet over the street center.

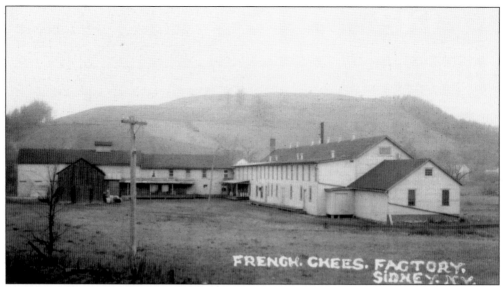

On June 8, 1901, Julian Bessard du Paro and George H. Garstin established the French Cheese Factory in Sidney. It was built on land located behind the River Street fire station. The factory produced the best French cheeses in the country, including Camembert, Bries, and Petit Suisse. Mr. du Paro died in 1906. The factory was sold to the Phoenix Cheese Company of South Edmeston, New York, in 1908. (Courtesy of Graydon Ballard.)

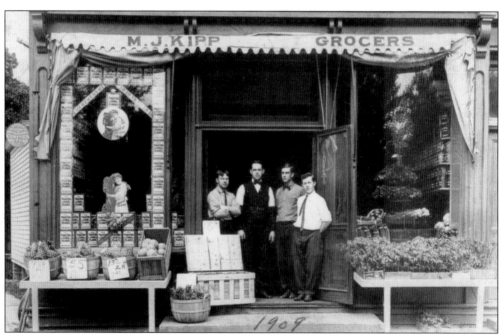

Myron Kipp began his grocery business in 1904 in a small building on the corner of Main and Bridge Streets across from the Congregational church. As his prospering business grew, he moved in 1910 to 11 Main Street, where he operated for 50 years, selling the business to Don D'Imperio in 1954. A pillar of the community, Mr. Kipp played a part in bringing Scintilla and Troop C to Sidney. (Courtesy of Graydon Ballard.)

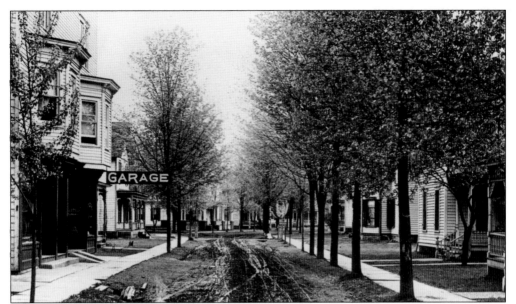

In 1906, Howe's Garage on Smith Street was the first and only garage between Binghamton and Oneonta. The building was a three-story block built by James Adelbert Howe and Frank Waldo Howe. The right side downstairs was the garage, and the left side began as a small grocery and soon became an office. On the second floor were four apartments, and various groups used the large third-floor room.

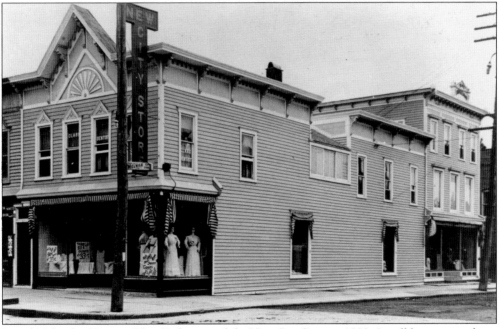

David Melnick of Roscoe, New York, opened the New City Store in 1909. A well-known merchant in his area, Melnick constructed a 25-by-40-foot, two-story building on the corner of Main and Division Streets. The store sold a fine line of ladies furnishings, millinery, cloaks, skirts, and waists, many of which were made on-site by several employees. Melnick went on to open additional branches in Roscoe and Schenevus.

In 1915, Cortland Cart and Carriage Company switched to manufacturing automobiles and became the Hatfield Automobile Company. Hatfield roadsters, suburban cars, touring cars, sedans, and coupes were greatly admired by the public. Orders were received from all over the country. These automobiles had the reputation of being very well built. Due to more competition and a depressed market, the business went bankrupt in 1924. (Courtesy of Graydon Ballard.)

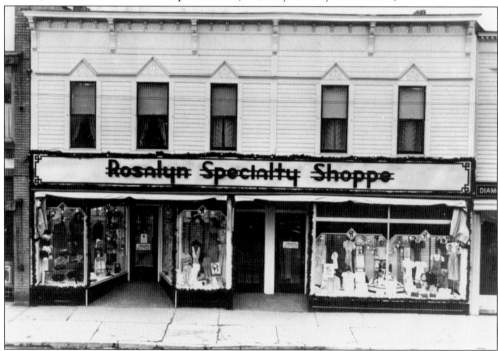

In 1928, David Melnick, being a shrewd businessman, decided to open a store completely devoted to ladies' fine wear. He called these stores Rosalyn Specialty Shoppes and had several locations in the area including Sidney, Norwich, Oneonta, and Cobleskill. He operated these branches beginning in 1928. His Rosalyn Specialty Shoppe occupied the business block he owned on Main Street. (Courtesy of Graydon Ballard.)

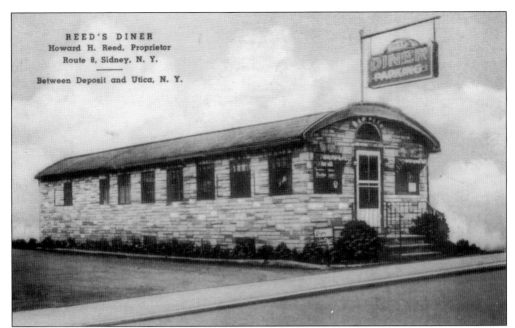

REED'S DINER
Howard H. Reed, Proprietor
Route 8, Sidney, N. Y.

Between Deposit and Utica, N. Y.

This small diner was first opened on July 15, 1939, by Miss Lindberg under the name of Lindy's Diner. It was located near the railroad tracks on the east side of Main Street. Under the ownership of Howard Reed, the establishment became Reed's Diner. It moved across Main Street in 1959, to the site of the old Star Lunch and Curly's Barbershop, which were razed. (Courtesy of Graydon Ballard.)

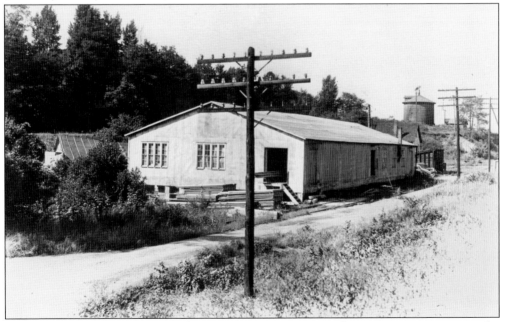

In the 1930s, the Sidney Handle Works was in operation on Willow Street Extension near the Ontario and Western Railroad tracks. It was located on the former site of the Sidney Glass Works. It later became a warehouse for Seven States Gas Company, which eventually became Suburban Propane, a business that continues to be operated locally.

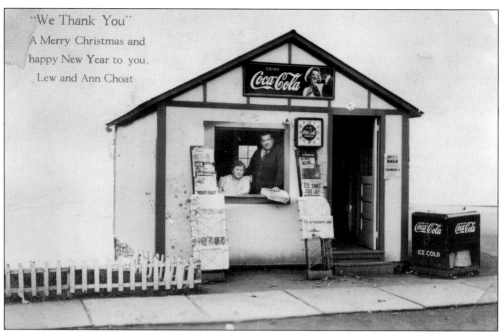

"We Thank You"
A Merry Christmas and
happy New Year to you.
Lew and Ann Choat

In the 1940s, Lew and Ann Choat had a small business located on Union Street near the east gate of the Scintilla plant. In their establishment, the Choats sold newspapers, magazines, candy, and soft drinks from their walk-up window. They also sold cigarettes, which were rationed beginning in January 1942 during the war. After their shift, workers quickly lined up when new supplies arrived. (Courtesy of Graydon Ballard.)

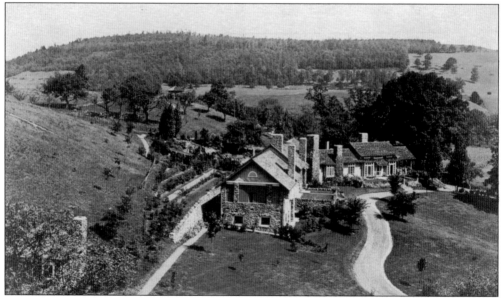

After some remodeling, Stonehenge Motel opened its doors to guests in the mid-1950s. Until the late 1960s, it catered mostly to businessmen who were visiting Scintilla and other local industries. Previously known as Meyers Bungalow, this fieldstone house was planned by Dr. William S. Myers in 1902. He built it as an extension to the wooden frame farmhouse that belonged to his grandparents. (Courtesy of Evy Avery.)

Four

CIVIC ORGANIZATIONS AND BUILDINGS

Johnston Settlement, Susquehanna Flats, and Sidney Plains were names for the village before it was changed to Sidney in 1886. Beginning with primitive conditions, the community gradually evolved into a civilized society. Sidney's citizens first provided civic services in private houses. Pioneer children were taught at home. A post office was established in 1823 in the home of Nathan Edgerton on Bridge Street. Sidney Private Hospital was located in two different residences in the 1920s. In 1925, the will of Mrs. George Arms designated her property on Liberty Street as a community house for the village.

Schools were built and replaced with newer schools as the population grew. After Sidney was incorporated in 1888, voters realized that other civic services required the construction of public buildings. Formally opened in 1910, the municipal building served multiple purposes. It was the village hall and also included the library, the fire department, and the police department. The second floor was used for recreational activities like exhibitions, dances, stage performances, and basketball games. It is now privately owned and used for several businesses. Buildings were constructed for the library, fire department, and recreation. Later the recreation center was replaced by the present-day civic center, a renovated school building. The town and village offices are also located in the civic center, with the recently constructed police station next door. Other public buildings include the post office, the hospital, Troop C headquarters, and the airport.

Member organizations such as the Moose Lodge, the Elks Lodge, and the Masons and military groups like the American Legion and Veterans of Foreign Wars (VFW) have their own buildings. Other civic organizations such as the Rotary, Kiwanis, town and country garden club, business and professional women's club, Daughters of the American Revolution, senior citizens, Boy Scouts, and Girl Scouts have met in places like the library, the community house, the recreation center, the civic center, churches, restaurants, and in members' homes. Essential government services and social opportunities have taken place in the town's civic buildings. They have been important factors in the quality of life in Sidney.

—Joelene Cole

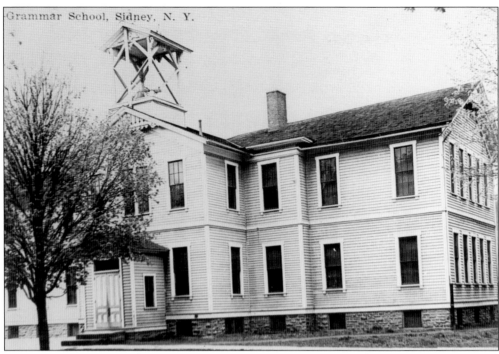

Above is the primary school building, constructed in 1872 at a cost of $3,000. It consisted of two rooms downstairs and one upstairs. An addition to the left was built and ready for use in September 1886 at a cost of $2,500. The addition to the right on the Pleasant Street side was constructed in 1888. The bottom photograph shows the wooden grammar school building facing Liberty Street. It was repaired in September 1904 and used until 1928. The 1904 renovations included improvements to classrooms and the addition of halls and classrooms. Toilets were placed in the basement and drinking fountains in halls. The total cost was about $5,000.

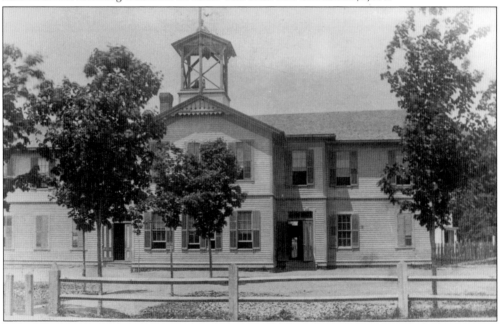

The Liberty Street School housed grades one through twelve when first built in 1872. From the April 16, 1885, *Sidney Record Enterprise*, "The fine report of our Village school will be read with interest. It is a showing of which the parents, teachers and friends of the school may well be proud of. Everyone is perfectly aware that a flourishing school exists in Sidney Plains. A school that is prepared to educate a child from primary classes and have them ready to enter college." In 1885, Sidney Plains school became known as Union Free School, then changed two years later to Sidney Union School and Academy. In 1890, when school reopened, something new was added—the first evening class ever held in Sidney was a special class in telegraphy with a tuition of $4 per term.

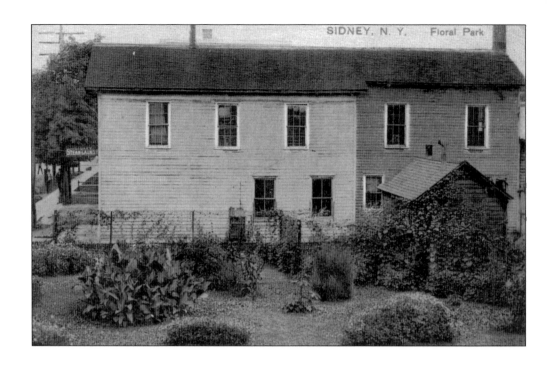

The first jailhouse in the village of Sidney (the small building to the right) has always been known as "Old Two by Four." It was built in late 1874 and was located at the corner of River and Grand Streets. Old Two by Four could only accommodate two prisoners at a time, and the cell contained just one bunk. This gave inmates no choice but to take turns sleeping, since there was not room in the bed for two, nor would the prisoners want to share. The key pictured here is from the old jail and is now part of the collection of local objects housed at the Sidney Historical Association.

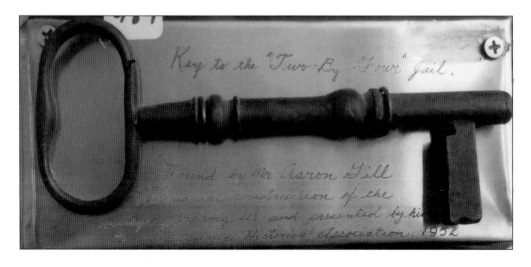

Sidney's first library was housed in a classroom of the school and opened to the public in 1887. This classroom library housed over 1,000 volumes. The Sidney Public Library was founded in 1895 and moved into the basement of the municipal building on the corner of River and Grand Streets in 1910, where it remained for many years. In 1945, land was purchased as a future library site on the corner of River and Main Streets, where the music hall had stood. In 1954, the original building in today's complex was erected. It was expanded to the present structure in 1991, and several further renovations have followed. (Below photograph courtesy of SCSAA.)

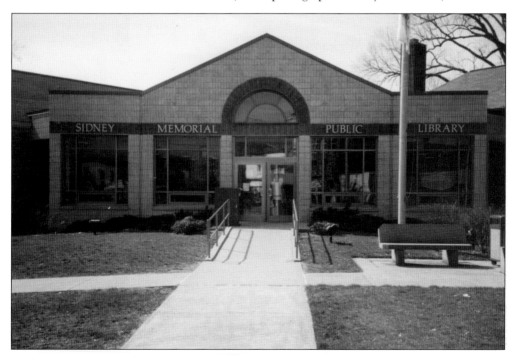

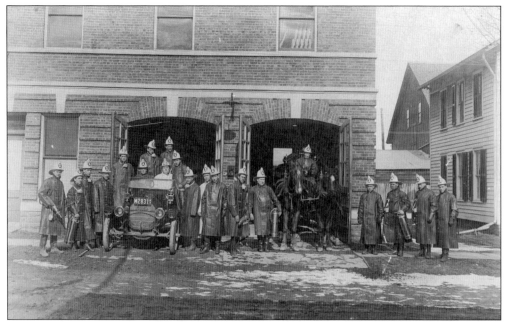

The H. G. Phelps Hose Company No. 1 was formed September 29, 1889. Their first fire was August 17, 1890, on Pleasant Street. Because there was no adequate fire alarm, the firemen could not reach the fire fast enough. To solve the problem, the Methodist Episcopal Church consented to permit them to use their church bell. The first piece of equipment purchased was a two-wheeled pumper for carrying hose.

Pictured is Sidney High School's class of 1891. From left to right are (first row) Rosette Johnston, Cora Young, and Cora Miller; (second row) Bryan Burgin, Grace Denio, Eugene R. Smith, Grace A. Wood, and Gardner Wood; (third row) Fred J. Hathaway, Ella Winsor, Ernest L. Young, Lena A. Bowen, Robert G. Sibley, Anna M. Johnston, John A. Clark Jr., and Edward A. Green.

Pleasant Street School was originally a high school. In 1891, voters approved construction costs of $18,000, which included 340,000 bricks and a slate roof. Forty years later, a newer school replaced the one on Pleasant Street that then stood vacant for 10 years. During World War II, it was renovated for defense industry training classes. Afterward this building served as an elementary school until 1969.

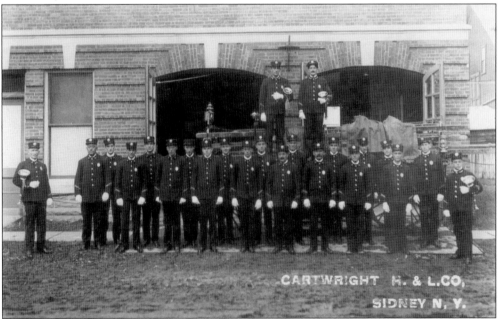

The Cartwright Hook and Ladder Company was formed on August 20, 1892. A joint meeting with Sidney's other firefighting team, the H. G. Phelps Hose Company, was held in April 1894 to elect officers for the Sidney Fire Department. Charles H. Seeley was elected as the first fire chief of Sidney. (Courtesy of Graydon Ballard.)

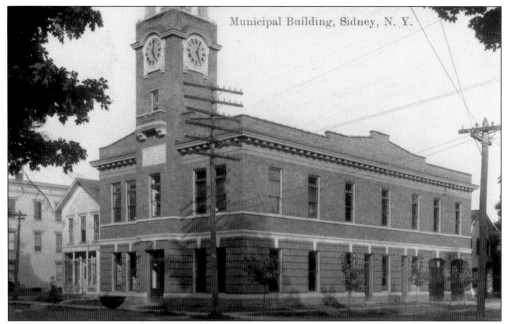

In 1893, voters approved the purchase of a site on the corner of River and Grand Streets for a municipal building. They did not, however, approve construction until 1909. Special features of the red brick, two-story structure included a wooden belfry, a 70-foot tower containing a heavy metal bell used for a fire alarm, and a clock that struck each hour. (Courtesy of Graydon Ballard.)

This photograph shows the schoolgirls of Sidney in approximately 1913. Pictured from left to right are (first row) Bertha Willis, Georgia Keeler Hodges, Esther Ruland, Myrtle Wilson, and Bertha Ives; (second row) Vinnie Rifenbark, Maude Gates, ? Boyd, Flora Wright, Florence Wilcox, and Fidelia Bard (Chestney), who herself went on to become a teacher in Sidney.

Sidney American Legion Post No. 183 was named after Charles Jacobi, a casualty of World War I. On August 7, 1919, a temporary post was organized, its first regular meeting held at the municipal hall on River Street. Dreams of having their own post home were always in the minds of members, and on December 6, 1949, they became reality with the erection of a new building on Division Street. (Courtesy of Graydon Ballard.)

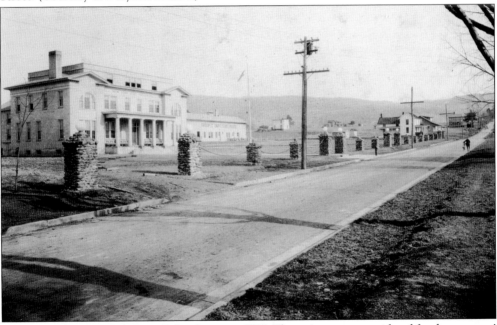

Troop C of the New York State Police began in 1921. Three sites were considered for the troopers' barracks—the fairgrounds, Riverside Park, and West Main Street. The immediate need of room and board for 58 men and their horses was unanticipated. Arrangements were made for rooms and use of the barn at the Central Hotel. The new barracks was dedicated and celebrated on the Fourth of July, 1922.

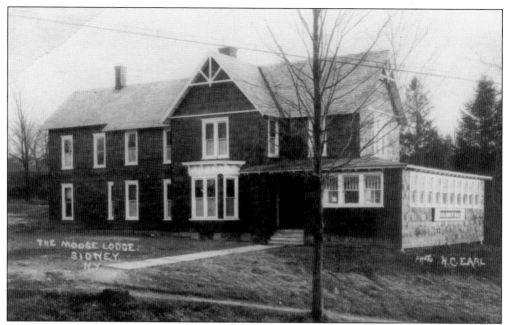

In 1922, the Loyal Order of Moose No. 277 purchased the Richmond block at the corner of Main and Liberty Streets. The chapter held many fundraising affairs, with the hard-earned money used to purchase a piano and various articles for the lodge rooms. In 1926, the Loyal Order of Moose sold the Richmond block and purchased the Bailey home at 20 East Main Street, the present Moose home. (Courtesy of Graydon Ballard.)

Sidney Reservoir No. 3 was part of the Pine Hill Reservoirs constructed in the early 1900s to 1936. Stored in these reservoirs were 240 million gallons of water for village use as a backup to the well supply when drought struck most of the country in late summer. The reservoir systems were operated in such a manner that the manipulation of two or three valves would bring the reservoir online.

The Sidney Private Hospital was located at 53 River Street. Mrs. Elizabeth Turk of Binghamton leased the house from Harry Thorndycraft, and it was under the supervision of nurse Nita Hanes and Grace Newton. In 1926, they purchased Dr. C. G. Bassett's property on Liberty Street with seven bedrooms. With extensive renovations came the purchase of the Vandkerwalker and Netzel properties on Clinton Street with 12 rooms and two bathrooms in 1928. On June 29, 1942, the town purchased 7 acres on Pearl Street for construction of a new hospital. The cornerstone was laid on August 6, 1942, and the hospital was dedicated and opened in August 1943.

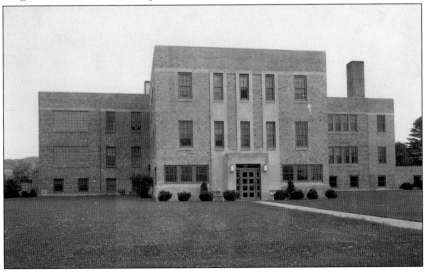

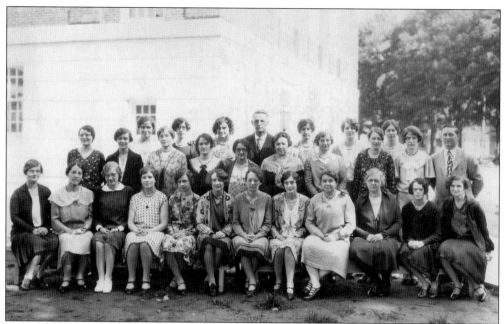

Sidney School faculty pictured in June 1930 are, from left to right, (first row) Anna Greene, Addie Fuller, Adah Loomis, Katherine Wohleschelgel, Della Chestney, Mary Frost, Myrtle Rhodes, Addie Goodale, W. T. Miller, E. J. Johnson, Marion Oagley, and Mary Ruland; (second row) Gladys Archer, Lena Sheldon, Grace Wood, Anna Maslin, Ethel Mae Doney, Fay Scott, Ella Parker, Dorothy Tate, Lydia Metz, and Willard Ruland; (third row) Fidelia Chestney, Bernice Weir, Dorothy Miller, E. J. Bond, Gladys Lodge, Marguerite Brooks, and Merle Herkstroter.

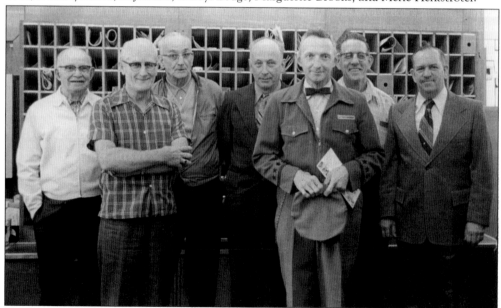

On January 1, 1930, free mail delivery commenced in Sidney six days a week, with in-town routes as well as in rural areas. Pictured above are some of the post office employees in later years. Standing from left to right are Andrew Dzurissin, Carrol Ostrander, Milton Ostrander, Victor Lockwood, Jack Cribbs, Bill Green, and Stuart Howe.

Pictured here is the Sherwood Heights School around 1945. The school was part of the Sherwood Heights Federal Housing Project, constructed to accommodate the vast numbers of people who came to work at Scintilla, producing magnetos and other airplane components for the war effort. The school and childcare building also housed a branch of the Sidney Library for this newly developed part of town.

The Ralph Arrandale Post No. 7914 of the VFW was started in 1946 with the hard work of Otto Ray and Kendall Hoke. The post home was constructed on West Main Street in 1948 with an addition in 1963. VFW members sell poppies each year, with the proceeds going to all veterans, their dependents, and orphans for rehab, welfare, and service work. (Courtesy of Graydon Ballard.)

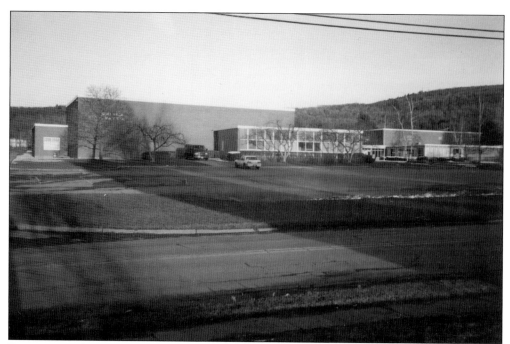

By a margin of almost three to one in 1957, voters approved a bond issue for the construction of a new high school. Purchase of the 22-acre tract of land adjoining Troop C barracks—which the voters had already approved to buy in 1955—on West Main Street was authorized, and the new Sidney High School was dedicated on November 15, 1959. (Courtesy of SCSAA.)

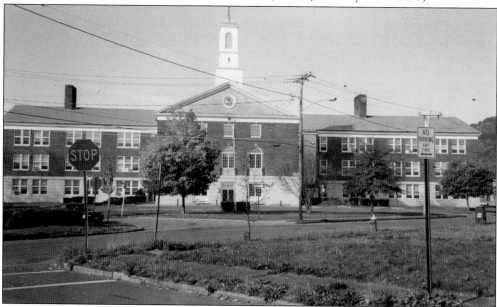

A dedication ceremony was held on March 14, 1981, for the Sidney Civic Center. The village board of trustees determined that the former school would be restored and used as a community building. People of all ages benefit from government services such as Head Start and Senior Meals, as well as recreational programs like sports and clubs that meet in this facility. (Courtesy of SCSAA.)

Five

CHURCHES AND CEMETERIES

As in all other places, religious faith is an important aspect of Sidney's history. After all, Sidney Plains was originally settled by Rev. William Johnston. Today it is easy to spot the religious meeting places that local families have developed over centuries as well as the final resting places for generations of Sidney residents.

In the early 1600s, French Jesuit priests were the first form of organized religion to visit the area. After the French and Indian Wars, England's support for the new colonies brought varying religions to the frontier from the Atlantic coast. Dutch settlements were soon overrun with Scottish, Irish, and German pioneers. Many were families seeking refuge from political and religious persecution.

A son of the area's founding father, Reverend Johnston organized Sidney's first "meeting place." Witter Johnston registered the first deed in 1797 for Sidney Plains in Delaware County. Colonel Johnston and other settlers accepted a land donation from tavern owner William Dovener to construct a church and burying ground.

The First Church of Christ was completed in 1808, known today as the First Congregational Church. The "burying ground," now the Pioneer Cemetery, is the resting place for most of the earliest settlers of Sidney Plains and its outlying area. The Methodist Episcopal Church was organized in 1831 in a building on Main Street. In 1871, a church was constructed on Liberty Street, its present location.

The building of railroads in the 1860s to the 1880s brought people and commerce to Sidney, as it was the crossroads of the Albany and Susquehanna, Ontario and Western, and the Delaware and Hudson Railroads. As Sidney grew in population, so did the need for different places of worship. This progress brought the formation of many new churches, including the First Baptist Church in 1881, Sacred Heart Catholic Church in 1893, and St. Paul's Episcopal Church in 1894.

Numerous religious and business leaders developed the Prospect Hill Cemetery Association of Sidney Plains in 1874 with great wisdom and necessity. The purchase of 17 acres made possible the final resting place for citizens of all religious faiths. This cemetery continues to be used today.

—*Mike Wood*

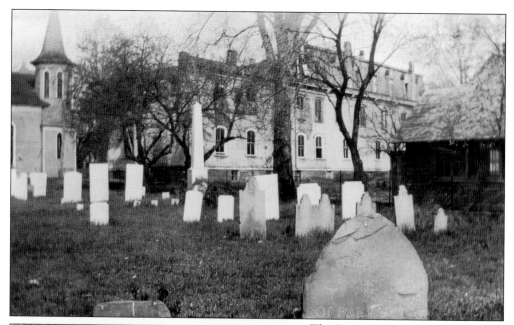

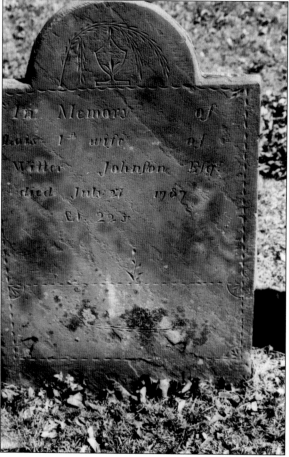

The Pioneer Cemetery is the resting place of many of Sidney's founding families. The first recorded burial in 1787 is of Lois Johnston, wife of Revolutionary War colonel Witter Johnston. There are nine Revolutionary war veterans buried here, including Israel Smith and his wife, Abigail Chandler Smith, the great-great grandparents of Pres. Rutherford B. Hayes. There are 241 markers in the cemetery, many now broken or unreadable, ranging from hand-cut slabs of fieldstone to crumbling sugar marble, dating from perhaps even before 1787. In 1806, William Dovener gave the land to be used as a formal burial ground and site of the Congregational church. A number of graves were moved to Prospect Hill in 1935–1936 when the new road and bridge were put in. The cemetery was accepted into the National Register of Historic Places in 2007.

In 1808, the Congregational church (formerly known as the "meeting house") was constructed 36 years after the first settlement of Sidney Plains. In 1839, it was turned from fronting on the Pioneer Cemetery to fronting on the street. The steeple was added and a bell was ordered. Never before had a church bell been heard here.

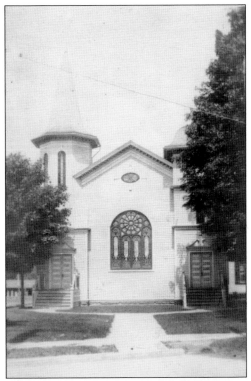

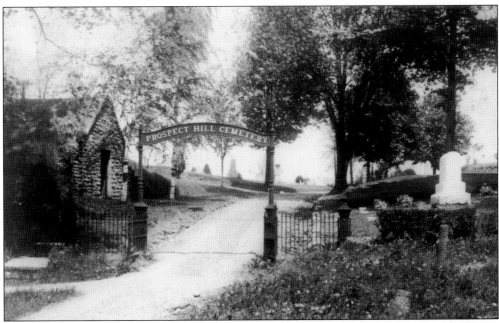

George King, R. Foster, R. Skinner, Miles Robinson, R. Winegard, E. H. Orwin, and Charles Bradford incorporated the 22-acre Prospect Hill Cemetery in 1874. The Pioneer Cemetery was full at this time, and many Civil War veterans could not be buried with the wives and children they had lost earlier. In 1894, iron gates costing $150 were added, and in 1896 the cemetery association added a fountain. (Courtesy of Graydon Ballard.)

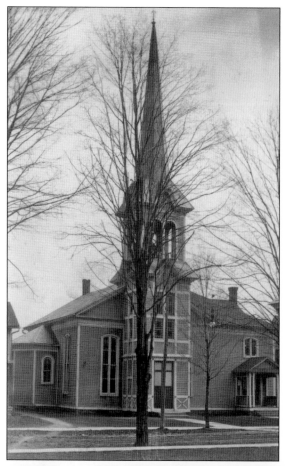

The first Methodist Church was built in 1831 at a cost of $2,000 on land donated by Arvine Clarke on Main Street where the Trackside Diner stands today. With the coming of the Delaware and Hudson Railroad, this location became very noisy, and it was decided to move the church to Liberty Street. On August 29, 1870, the church was moved and remodeled. Modern pews, stained glass windows, new carpeting, and an addition were completed in 1885, the church bell hung in 1889, and an addition to the west side finished in 1892. The parsonage was constructed in 1888 on a lot adjoining the church. The present church building was completed in 1934, and on Palm Sunday, a dedication service was held. The church was again enlarged in 1948 and 1963, with a new parsonage completed in 1953.

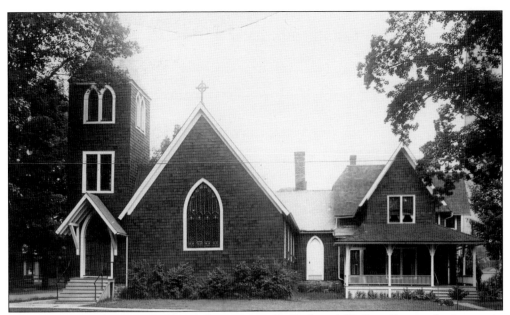

The first Episcopal services held in Sidney were at the Redman's Hall on Cartwright Avenue in 1876. In 1896, the Episcopal church and rectory were built on the corner of River and Clinton Streets as seen here. On Christmas Day 1943, fire destroyed the church and damaged the rectory. A new church and remodeled rectory were dedicated on August 5, 1951.

In 1873, the Methodists bought land on the edge of the village beginning what became known as the "Camp Grounds." The grounds were graded, buildings erected, and a tabernacle built. Trains in and out of Sidney were loaded with people headed to the Camp Ground meetings. This photograph shows the dirt road wagons would use to carry passengers from the railroad cars to the Camp Grounds. (Courtesy of Gordon Ballard.)

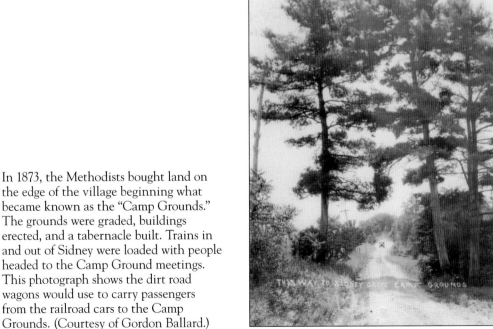

The Sidney Grove Camp Meeting Grounds was established in 1873 by the Sidney Grove Camp Meeting Association, in conjunction with the Methodist Episcopal church conference. A 10-acre knoll overlooking Sidney Plains was purchased in 1874, and an additional 10 acres was added a few years later. The faithful and the simply curious came from all over Central New York and from as far as Wilkes-Barre, Pennsylvania.

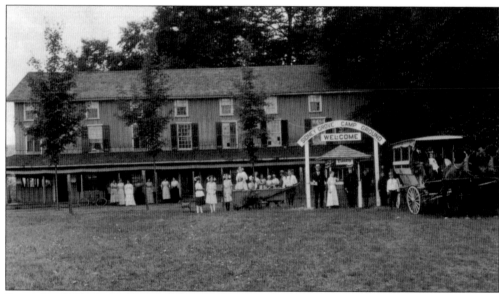

Erected in 1884, the buildings at the entrance to the Grove consisted of an administration office, a large dining hall, boarding hall, and a dormitory. The dining hall often fed up to 1,000 people a day, while the boarding hall and dormitory could accommodate 500. There were 30 rooms for families at $5 per week, with or without furniture. The Ontario and Western Railroad ran special weekend excursions to town. (Courtesy of Evy Avery.)

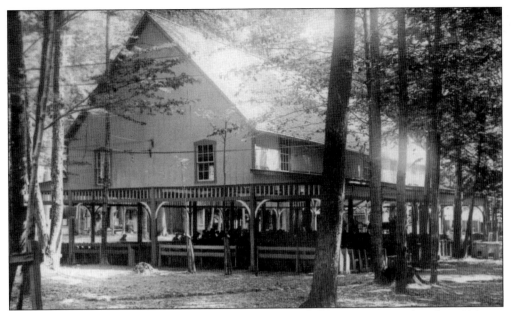

The centerpiece of the Grove was the Tabernacle. Completed in 1885, it replaced a 1,000-seat canvas tent. It was shelter from rain and a place for daytime children's activities. A raised platform for the speakers also housed a Story and Clark pump organ. In 1901, electricity replaced pine knot torches used for light. Sunday crowds numbered up to 10,000 with as many as 1,200 teams of horses providing transportation. (Courtesy of Evy Avery.)

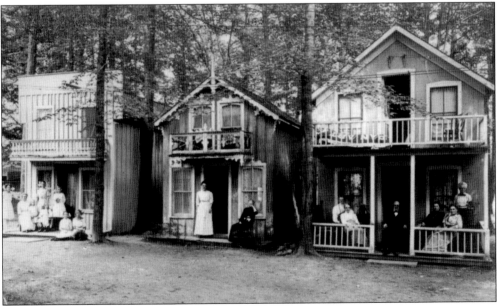

Forty-six cottages were situated in a wide circle around the Tabernacle at the Sidney Grove Camp Meeting Grounds. Many were privately owned and used or rented throughout the summer. Various church groups in the conference built others. The Sidney Grove's 70-plus-year history ended in the mid-1940s when the Wyoming Conference sold it. Today it is a housing development. (Courtesy of Evy Avery.)

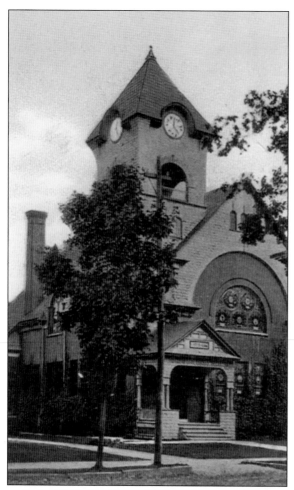

Fourteen members organized the First Baptist Church on November 10, 1868, at the home of Enoch Harrington on River Street. On December 23, 1868, the Baptist church council met at the Methodist church to reorganize as a regular Baptist church. On November 11, 1879, a definite plan for a church building on Clinton Street was presented for members' consideration. The first church building was dedicated on May 17, 1882, with Rev. L. M. S. Haynes of Binghamton preaching. By 1893, membership growth made a larger church necessary. The River Street site was purchased on September 24, 1894, and the Clinton Street site sold. The completed First Baptist Church on River Street was dedicated on March 10 and 11, 1896. This building was demolished in 1968 to make space for the present larger church. A parking lot was added in 1978.

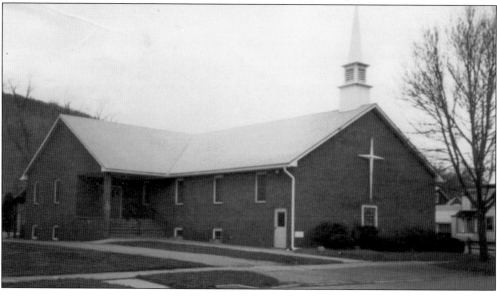

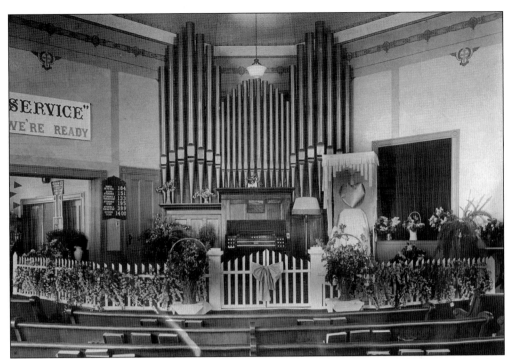

May 1924 was a joyous time for the Sidney Baptist Church. At this time, the new organ they purchased was received from Ohio. Mr. Beman of Binghamton traveled to Sidney and assembled the Holbrook and Ware organ, which was complete with 18 stops and at least 900 speaking pipes.

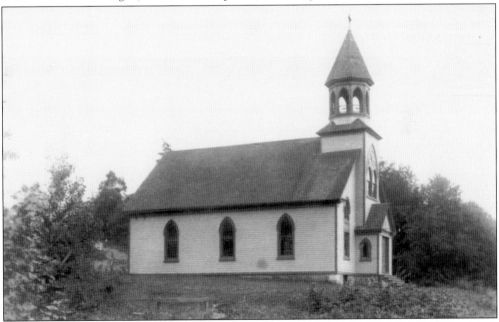

The church of the Sacred Heart on Liberty Street was built in 1925. Sidney's first Catholic church was built on East Main Street near the present Moose Club in 1893. The ice and snow of winter and the mud of spring made it difficult to climb the steep hill—even so, it remained until it outgrew its capacity of 60 people and the new church was constructed.

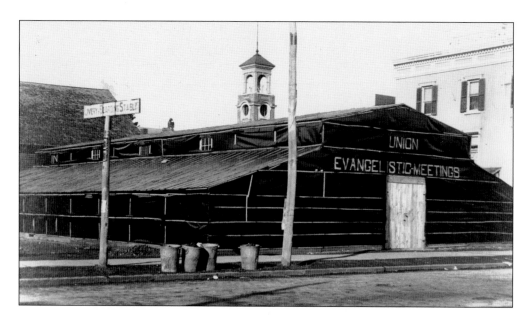

Union evangelistic meetings were held to convert individuals to Christianity. A tabernacle that seated 1,000 people for revival services was built in just three days in March 1910 on Main Street close to the corner of River Street. In February 1915, an evangelistic campaign declared a tabernacle would be set up on the Barker property at the corner of River and Union Streets. A choir of 90 voices would sing and speakers would preach the gospel. These meetings stimulated renewed interest in religion. It was reported that after religious revival meetings in January 1906, the Congregational church added 61 members, the Methodist Episcopal church gained 40 members, and the Baptist church acquired 30 members. (Below photograph courtesy of Graydon Ballard.)

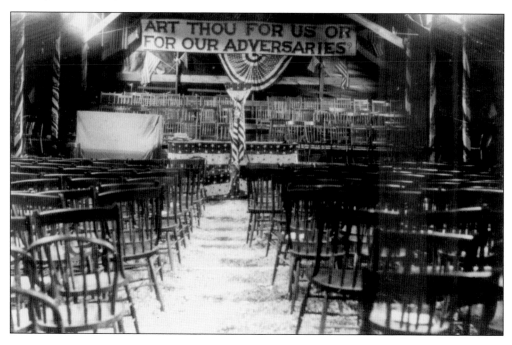

The First Southern Baptist Church was originally the Christian and Missionary Alliance Church when it was built on the corner of West Main and Adams Streets in 1944. As the original congregation outgrew the structure, the Southern Baptists purchased it from them. This picture was taken in May 1997. In 2004, the property was sold again and became the Faith Community Church.

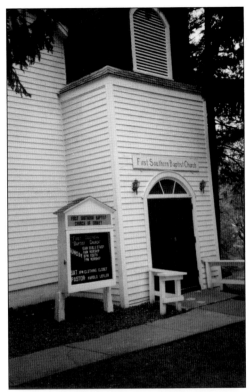

After using the Village Community House for Sunday services, the congregation approved West Main Street as the site of construction for the new Christian and Missionary Alliance Church in 1944. A name and site change became necessary when the congregation grew too large for this building. Thus the Circle Drive Alliance Church came into being when the present church was constructed on Circle Drive.

Before 1952, Sidney Lutherans attended services in either Norwich or Oneonta. To establish a church, a charter membership of 50 adults was necessary, and in that year the requirement was met. Services were held at the VFW until a Church Chapel was constructed in 1958. A larger building was constructed on West Main Street in 1966 due to increased membership.

Kingdom Hall on Patterson Street was dedicated on April 26, 1986. The occasion's program included a talk about the history of the local congregation of Jehovah's Witnesses as well as a slideshow of the construction of the building. Presiding minister Alexander Coufos thanked about 200 people who attended the dedication for their cooperation and help. The hall was completed in just two days.

Six

RECREATION AND CELEBRATIONS

In the wilderness of the Johnston Settlement, pioneers learned to canoe, swim, fish, and hunt just to survive. The Susquehanna River and surrounding forests have been handy for recreation, too. As Sidney became more civilized, facilities like Daniel's Bath and Boat House, East Sidney Dam, Sidney Pool, and DelChenango Rod and Gun Club became available for residents to experience the outdoors safely.

For almost 100 years, the primary social centers of the community were the churches and the school. These institutions still serve as important sources of social activities. By the late 19th century, businesses, civic organizations, and special interest clubs also provided opportunities for people to gather together for food, drink, fellowship, fun, and entertainment. Concerts, dances, lectures, plays, movies, and other amusements have been offered for the enjoyment of the public.

A pasture on Cartwright Avenue was used as a baseball diamond in 1874. Since then, leagues have been established for men, women, boys, and girls in many different sports. People have spent their leisure hours at places like the recreation center, Keith Clark Park, the bowling alley, and the golf course, as well as other sites.

Sidney has a tradition of celebrating with parades. The first major event was the Centennial Jubilee on June 13, 1872. Festivities included a parade, speeches by descendants of early settlers, and a free dinner for over 1,000 attendees. Parades honoring veterans have been held since 1886. Sidney's 1972 bicentennial parade had an estimated 15,000 spectators. Two historical pageants and the publishing of two historical books marked the celebration. Four years later, the Sidney Spirit of '76 Celebration involved a parade, a bicentennial ball, and a pageant. In June 1992, Gov. Mario Cuomo marched in the town's New York State Police 75th Anniversary parade. The tradition continues with Memorial Day, Hometown Day, Veteran's Day, and Jolly Holly Day parades.

Class reunions have also been occasions for celebration. The Sidney Central School Alumni Association (SCSAA) has reunited students, faculty, and staff with a variety of activities during alumni weekend in July and homecoming weekend in October.

—*Joelene Cole*

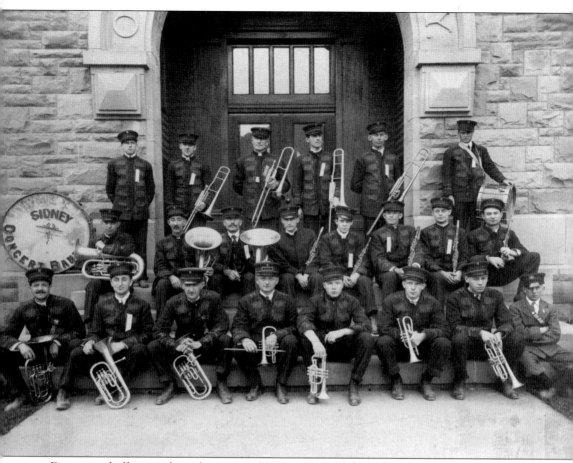

Determined efforts made in the spring of 1882 to reestablish a village band were met with much success. All appreciated a village band playing on Main Street every Saturday evening, and the community had plenty of talented musicians to make this a reality. A good band made for a lively Saturday evening concert.

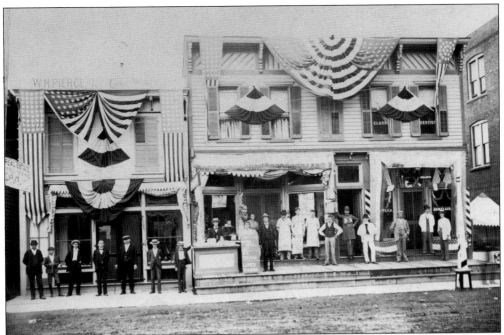

These Main Street businesses were decorated with bunting for a special occasion. C. H. Poke took this picture on August 5, 1897, when the First Annual Convention of the Delaware County Firemen's Association was held in Sidney. A highlight of the convention was a big parade. A local newspaper reported that approximately 7,500 people watched it. The firemen lined up for the parade at the Central House on River Street. At that time, the streets of Sidney were not paved, so the firemen marched on the dirt pathways. Sidney provided 1,200 dinners and suppers for the visiting firemen. They ate in a huge tent set up for them.

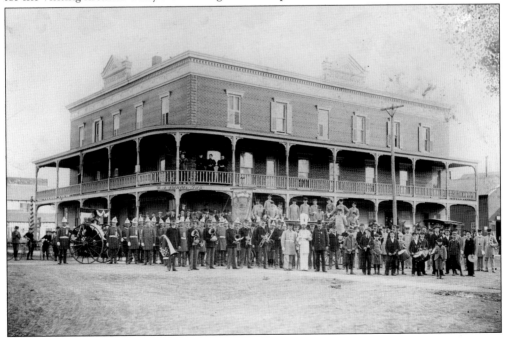

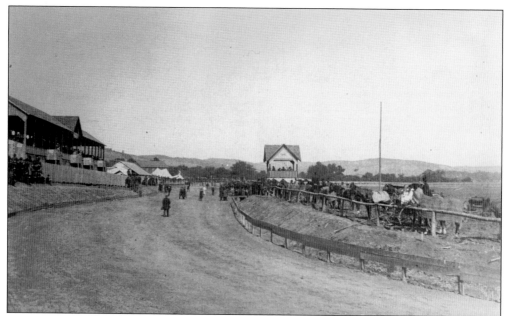

The Tri-County Fair was held annually at the Sidney Fairgrounds from 1891 to 1894. When the property was sold in 1895, the Sidney Fair was established. This event only lasted until 1897, because the Ministerial Association of Sidney objected to the "demoralizing influence" of the fair. The fairgrounds site was near the present locations of Una-Lam and MeadWestvaco.

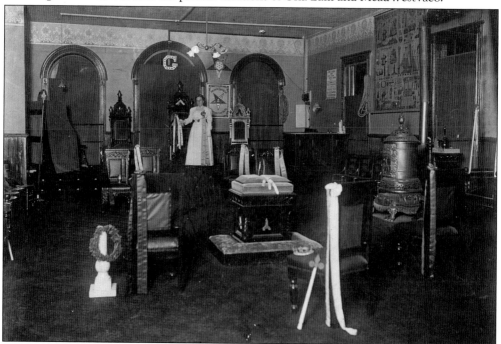

Sidney's Eastern Star chapter was organized with 27 members in May 1902. Ladies worked laboriously to raise money, sometimes by knitting hats, scarves, socks, and sweaters for care packages for military men. Continued growth made larger quarters necessary, and a new Masonic building on Union Street was completed in May 1965.

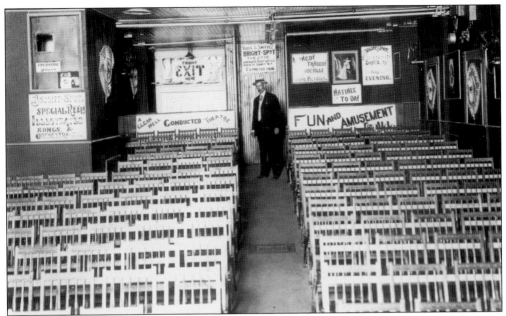

On August 15, 1908, Bright Spot Theatre opened in the Smith Block. Russ Smith made many improvements to the interior of the theater, including enlarging the auditorium, removing a post that blocked the view, expanding the exits to five, and building a new pit for the orchestra. This theater was well attended for over eight years; however, when attendance declined, it closed on March 13, 1916. (Courtesy of Graydon Ballard.)

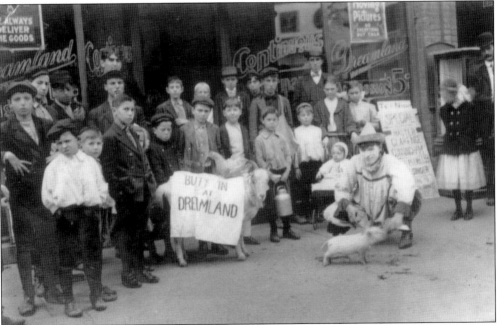

Dreamland, a theater located in the Spencer Block, opened on August 1, 1908. It featured illustrated songs by Miss Fannie Keith every night as part of the show. Special entertainment included Lahone the Oriental magician, an acrobatic exhibition, and a vaudeville show. Although the theater was popular, it shut down before the end of the year. (Courtesy of Gordon Ballard.)

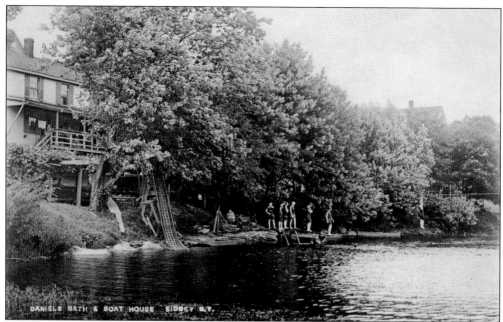

Located on Riverside, downstream from the old iron bridge, Daniels Bath and Boathouse was a popular rental and swimming area in the early 20th century. Note the waterslide. The Pioneer Glass building now stands where the house was located. Eventually the state road (Route 7) was straightened, the course of the river changed, and the site is now north of the road. (Courtesy of Graydon Ballard.)

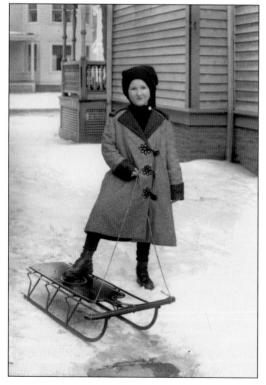

Sleigh riding was a popular wintertime activity. Sleds similar to this one were manufactured at the local Sidney Novelty Works. Perhaps this proud young lady received the sled as a Christmas gift from Santa Claus. Notice her high button shoes and handsome coat. This photograph is from the early 1900s.

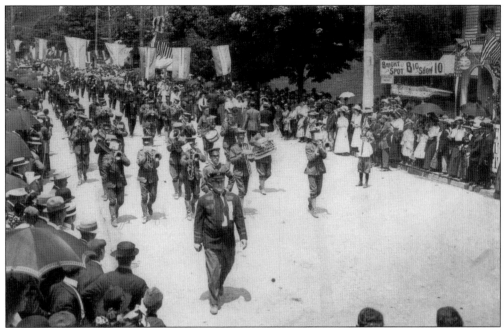

On Thursday, June 24, 1909, the 13th annual tournament of the Delaware County Firemen's Association was held in Sidney. That morning, 51 fire companies, 15 bands, and three drum corps participated in the parade on Main Street. Thousands of spectators cheered for the 1,164 marchers. Other activities that day included hose and hook-and-ladder races as well as a baseball game. (Courtesy of Graydon Ballard.)

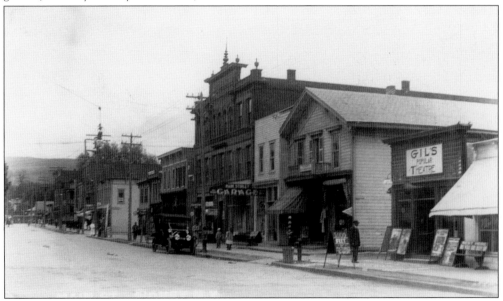

Gil's Theatre opened on March 18, 1911. Edward H. Gilday, manager, said poor children could attend at least one matinee a month for free. Over 350 people attended 5¢ nights in February 1912. Mrs. Anna Taylor, who went over Niagara Falls in a barrel, attracted large audiences in June 1913. She talked about the pictures of her Horseshoe Falls 1901 adventure. By 1914, competition from other theaters resulted in Gil's Theatre closing.

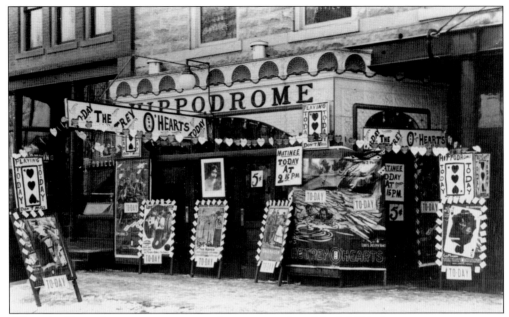

When the Hippodrome moving picture theater opened on July 4, 1914, there were two programs as well as a citizens' orchestra for entertainment. The theater was "equipped with every modern device" such as eight electric fans for cooling, screens of the best designs, and perfect lighting. Every night of the week, a "clean program and excellent pictures" could be enjoyed in the 300-seat theater.

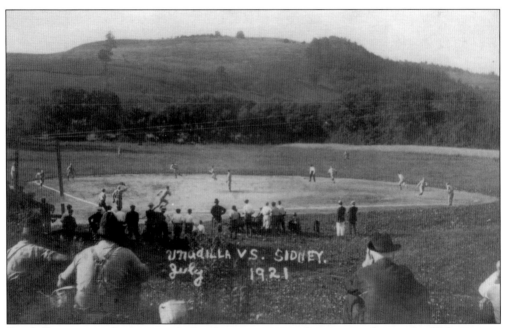

Baseball was a popular pastime for local participants and spectators during the 20th century. A public playing field was made off River Street that still exists today. Teams from all over the neighboring area competed in well-attended games, and the crack of the bat could be heard up and down the Susquehanna River. (Courtesy of Graydon Ballard.)

In 1922, Fanny Loomis organized the first Sidney Girl Scout troop with nine members. By 1955 there were 295 Girl Scouts with six Brownie troops, eight intermediate troops, and one senior troop. These Brownies enjoyed showing off their spring hats in May 1960. Scout membership has continued to be available to all girls in Sidney. (Courtesy of Vicki Miller Kulze.)

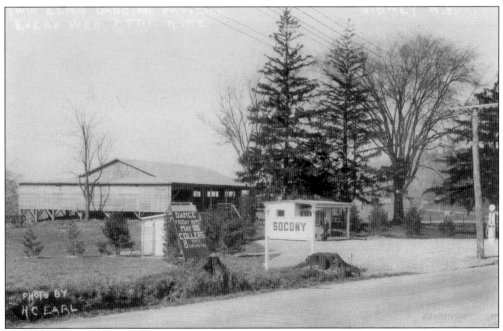

The Twin Elms Pavilion, built by J. H. Bedell in 1925, was one of the best-known dance locations along Route 7. Located 1 mile out of Sidney on the Unadilla road, the pavilion burned to the ground in a blaze on Sunday, October 20, 1935. (Courtesy of Graydon Ballard.)

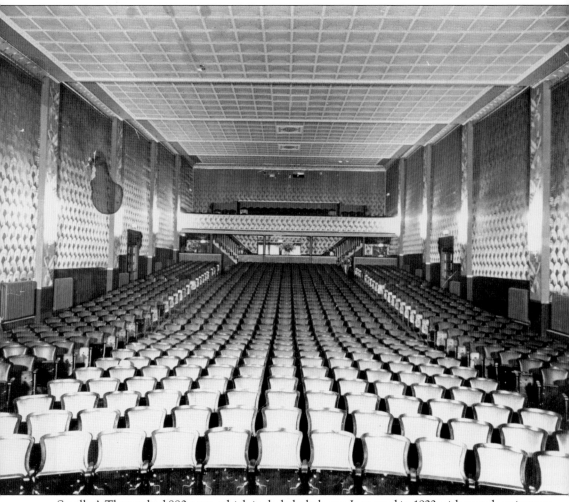

Smalley's Theater had 880 seats, which included a balcony. It opened in 1922 with sound equipment installed in 1929. Performances included silent movies accompanied by live music, vaudeville acts, and talkies. Personal appearances by Roy Rogers, Tom Mix, and Gene Autry to promote their Westerns at Saturday matinees drew 3,000 people. In 1957, Smalley's was sold, but the building remained a theater until 1997.

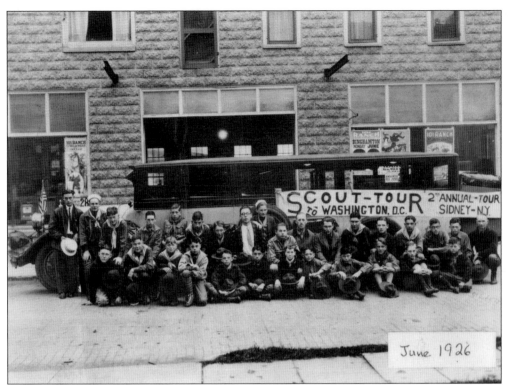

June 1926

In 1923, Boy Scout Troop 34 was established. Cub Scout Pack 34 and Troop 34 have a scout room in the Methodist Church. Sacred Heart Catholic Church chartered Troop 88 and Cub Scout Pack 88 in 1943, and the groups continue to meet there today. In 1961, Troop 99 was formed. The Congregational church hosts this troop.

The Sidney Golf and Country Club was organized in April 1926 after 10 men supplied the required funds to buy the 44-acre Crawford farm located on Masonville Road. C. P. DeWitt was in charge of transforming the land into a golf course. It opened with four holes in July 1927. By spring of 1928, nine holes were open for play. (Courtesy of SCSAA.)

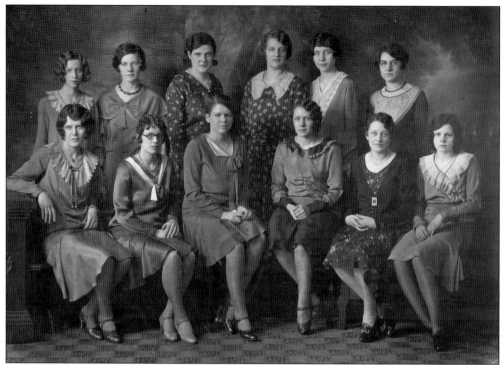

Delta Gamma Delta Sorority's goals were to do charitable and literary work. The girls held dances, food sales, and movies to raise funds. Members pictured in 1929 are, from left to right, (first row) Florence Walker, Florence Laraway, Vivian Johnston, Evelyn Spencer, teacher Dorothy Tate, and Catherine Spencer; (second row) Victoria Walker, Marjorie Smith, Elizabeth Cook, teacher Marguerite Brooks, Audrey MacGregor, and teacher Lydia Metz.

Ray Hall built the Hillcrest Roller Rink on West Main Street. It opened on January 1, 1929. Many birthday parties and events for community, church, and school groups have taken place there. People as young as three and as old as 80 have enjoyed skating at the rink. Hillcrest has had several owners over the years and is still in business.

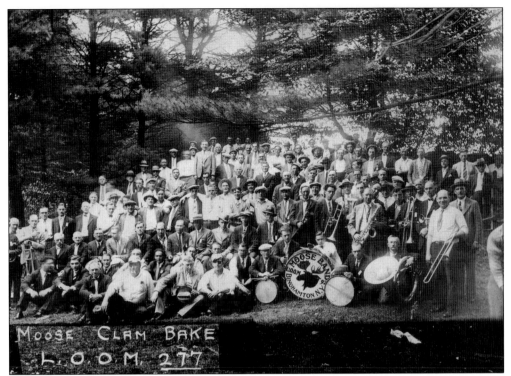

How many clams would be enough for a clambake? The answer is uncertain, but people rarely confine themselves to eating just clams at such events. They also enjoy other foods and play games and music. Clambakes are relished by all, as evidenced by these Sidney Moose Club members in 1929.

Earliest records show a Sidney Home Bureau exhibiting at the New York State Fair in 1933. Each monthly meeting held a special program ranging from refinishing furniture, flower arrangements, restyling hats, sewing, and so on. This photograph was taken at the home of Mrs. Werner Grutter where she hosted that month's home bureau meeting.

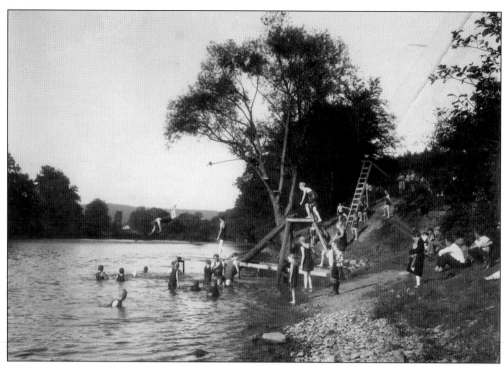

Sidney's favorite old swimming hole during the 1940s and early 1950s was known as Miller's and was located on the Unadilla River above the junction with the Susquehanna River. This swimming hole came complete with stairs built into the riverbank up to a rope swing, which allowed the daring to swing out over the river, let go, and hurl down to its refreshing depths. Each summer weekday, coach Harry DeBloom used a bus to drive children from the recreation center to Miller's. He was their lifeguard and mentor and made many a youngster's childhood memories of a cool, refreshing old swimming hole complete. (Above photograph courtesy of Graydon Ballard; below courtesy of Bonnie Curtis.)

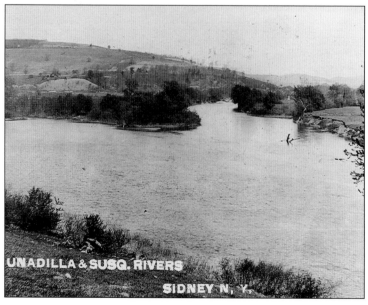

The Scintilla Gun Club held its first meeting on February 18, 1935. They purchased a building on River Street, which was originally a silk mill. The club's rifle and pistol teams distinguished themselves by winning top honors in competitive shooting in several Southern Tier leagues. Eventually the club disbanded and the building was sold to the Elk's Lodge, its present occupant.

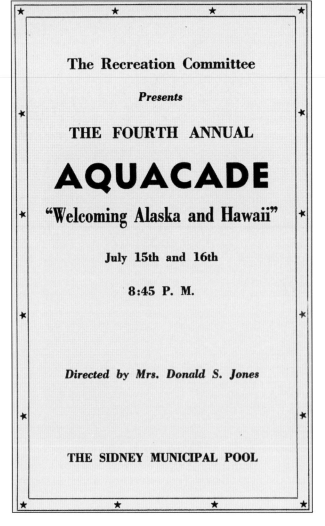

The Recreation Committee

Presents

THE FOURTH ANNUAL

AQUACADE

"Welcoming Alaska and Hawaii"

July 15th and 16th

8:45 P. M.

Directed by Mrs. Donald S. Jones

THE SIDNEY MUNICIPAL POOL

Sidney had long talked of having a swimming pool, and in 1950, village officials and the community united to turn talk into action. The first money collected for the swimming pool fund was $281 from a scrap metal drive in 1951. Steel arrived for construction of the swimming pool in August 1953, and it was filled with water on October 1, 1953. The Sidney Pool was dedicated on Monday, July 5, 1954. The first annual water carnival was held on Labor Day 1954, with close to 100 entries in various competitive events. When the pool opened for the season on June 27, 1955, over 700 people used it. In 1957, Taffy Jones directed the first "Aquacade," which was an immediate success. In July 1958, the Aquacade drew over 1,000 paid admissions for two nights.

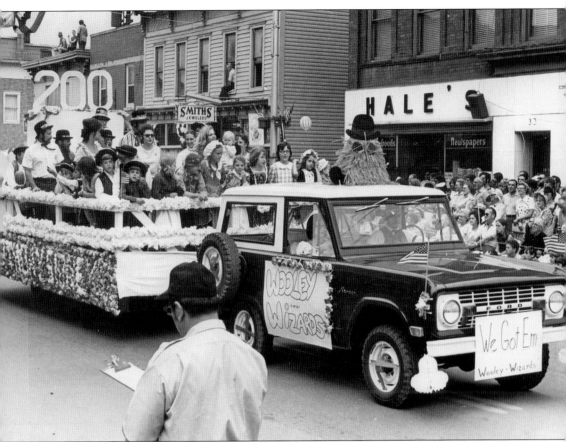

Bicentennial activities were scheduled each day from July 1 to July 8, 1972. On the last day, one of the biggest events was held. A gigantic parade featured floats, bands with color guards, drum and bugle corps, fire departments, antique cars, and horses. "Bicentennial Belles" dressed in colonial gowns while "Brothers of the Brush" grew beards for the celebration. An estimated 15,000 people enjoyed the mammoth parade.

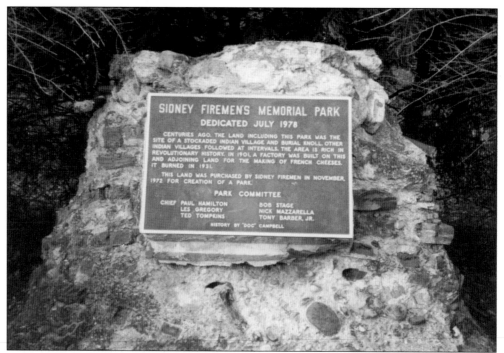

In November 1972, the Sidney firemen bought land near River Street Fire Station to create a park. This land had once been the site of a Native American village. Many years later, a cheese factory occupied the site. Sidney Firemen's Memorial Park was dedicated in July 1978. Firemen's Field has been further developed to include a pavilion, rest rooms, part of a walk and nature trail, and a playground.

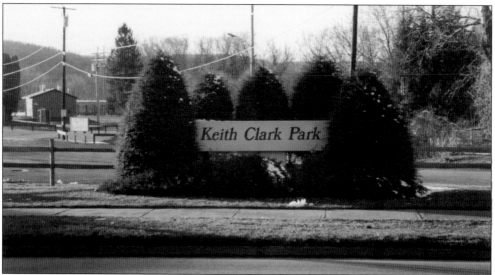

The athletic facilities at Keith Clark Park on River Street have been used for both school and community sports. Teams play baseball, softball, football, soccer, basketball, volleyball, tennis, and horseshoes. Individuals have used the skating rink, playground, and nature trail. Maintained by donations from MeadWestvaco, Sidney Community Foundation, and the Village of Sidney, this park has been a destination for outdoor recreation for decades. (Courtesy of SCSAA.)

Sponsored by Rotary Club of Sidney Community Foundation, the Walk and Nature Trail opened in August 1997. Located at Keith Clark Park and Firemen's Field, it was funded with donations and built by village workers plus volunteers. Gardens, floral markers, educational signs, picnic areas, benches, water fountains, bird feeders, and a covered bridge have been installed along the trail. People enjoy its river views and wildlife.

This production of *Arsenic and Old Lace* was performed on the high school stage in February 1981. The actors are, from left to right, Allen Duke, Jeanne McClelland, and Joyce Schroth. In 1963, local chambers of commerce established Tri-Town Theater with Jack Deuel as director. Three or four plays a year continue to be presented for the enjoyment of the public.

Seven

RAILWAYS, HIGHWAYS, AND SKYWAYS

The area today known as Sidney was a transportation juncture long before Reverend Johnston arrived. The confluence of the Unadilla and Susquehanna Rivers made this an important spot for Native Americans before the Europeans settled, using water highways to trade and farm. For centuries, the rivers were the main routes of transportation but, after the American Revolution, a Native American trail became the dirt road that is now Route 7. This highway ran on the other side of the river from Sidney, and commerce bypassed this village. A covered bridge eventually connected Sidney to this transport route. There were ferries; however, the size of the river limited their capacity.

By the mid-19th century, railroads were being developed. Delayed by the Civil War, the Albany and Susquehanna Railroad came to Sidney around 1870. This route passed through Sidney, rather than around it like the dirt road, giving the village a stronger connection to the world. Other railroads, such as the New York and Oswego Midland and the New York Ontario and Western came through Sidney, and it became an important transfer point for trade.

Because of the railroads, industries found Sidney attractive and located along the tracks. Bendix prospered through its proximity to the railroads, and because of the company's involvement with aviation, Sidney developed an airport. The original airport was located near the mouth of the Unadilla River; later a larger one was built at its current location on Gifford Road. Much of the fill for the present-day Route 8 through that area came from this older airport. Sidney's transportation modes have always been intertwined.

Another important transportation avenue in Sidney is Interstate 88. This divided highway was built to connect the Southern Tier with the capital district, similar to the original railroad through town. I-88 made Sidney even more accessible to the rest of the world. Some argue that interstates have been a downfall for small communities like Sidney, while others feel that they have made it possible for people to live here and travel elsewhere for work. Either way, transportation continues to transform Sidney as it has throughout the centuries.

—*Alfred Olsen*

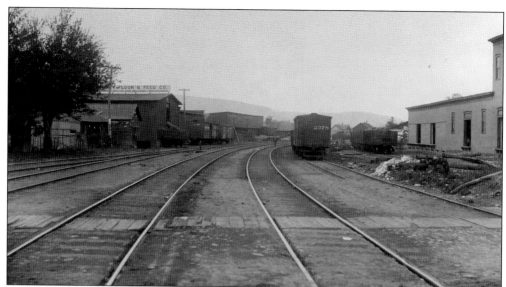

The original purpose of the Sidney Flour and Feed building, constructed in 1887, was to store flour and feed, but owner A. B. Martin decided to also establish a business for grain and produce. In 1895, new owners H. G. Phelps, C. G. Brooks, and O. T. Angell expanded Sidney Flour and Feed to a three-story building with a series of coal sheds, now also dealing in seeds, salt, brick, lime, cement, and coal.

Believe it or not, this photograph is of Delaware Avenue looking east, back when it was a dirt road. Today the Easy Mart convenience store and Laser carwash would be in the background, at the far end of this road. A portion of a bridge can be seen going across the creek where Amphenol's south gate now stands.

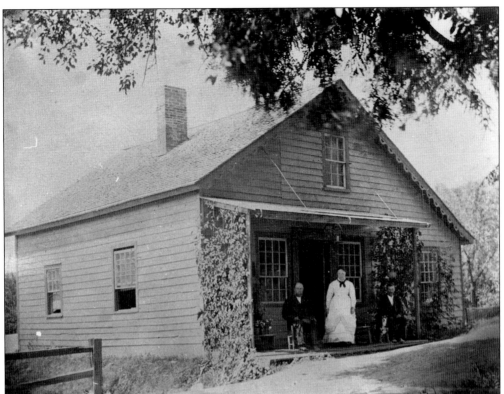

Joe Moore, born in 1910, remembered his parents buying the tollhouse by the iron bridge on Bridge Street in 1929. "Old Man" Hyatt, who collected tolls for the wooden covered bridge built across the Susquehanna River in 1852, previously owned the tollhouse. Tolls were 2¢ for people on foot, 12¢ for a horse and buggy or sleigh, and 25¢ for anything drawn by two horses, two mules, or a team of oxen. The bridge was one of only eight toll bridges left in New York State when, in 1894, it was condemned as unsafe for traffic. A toll-free iron bridge constructed in 1894 was to last 100 years, but became inadequate with the advent of the automobile. This route remained Sidney's connection to Bainbridge and Unadilla until 1936, when Main Street was extended across the river.

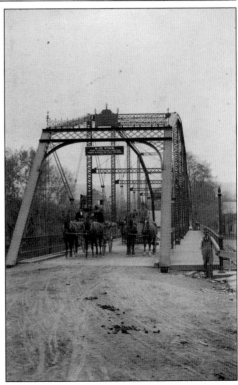

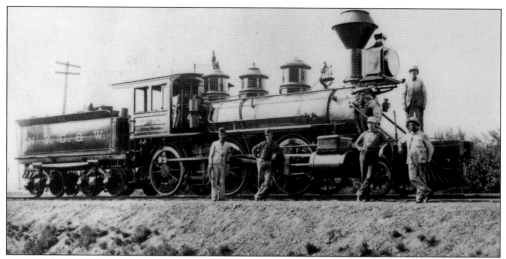

Around 1892, these five men proudly posed with their locomotive engine for the photographer. Their names are, from left to right, Frank Pinch, Frank Arnold, Dave Newton, Reuben Chase (standing on the train), and John Dudley. Shortly after this time, Dudley became a porter for the Pullman Car Company out of Roscoe, New York.

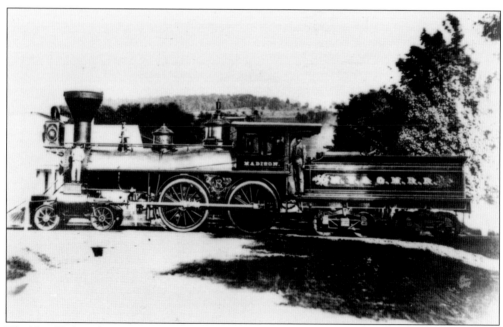

The New York and Oswego Midland (NY&OM) Railroad was created to bring Pennsylvania coal to Oswego's port. They received their coal from the Delaware and Hudson line that interchanged their cars in Sidney. When steam engines were named, the Madison brought one of the first trains of the NY&OM into the village. This railroad became the New York Ontario and Western not long after arriving in Sidney.

This station was built by the Delaware and Hudson (D&H) and New York and Oswego Midland Railroads. It was the largest board and batten station on the Ontario and Western. The D&H was on the north side, the O&W on the south, and Main Street on the east. A more modern station was built on this site in 1913. Today the original station, after many renovations, houses Mang Insurance.

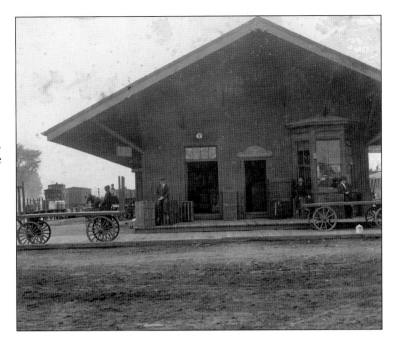

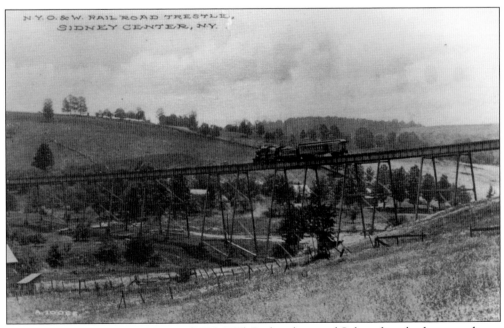

The New York Ontario & Western (NYO&W) Railroad entered Sidney from both east and west on some impressive trestles. This particular trestle in the hamlet of Sidney Center was a good example of what the railroad workers were capable of building. The concrete footings at the base are still visible in the community today.

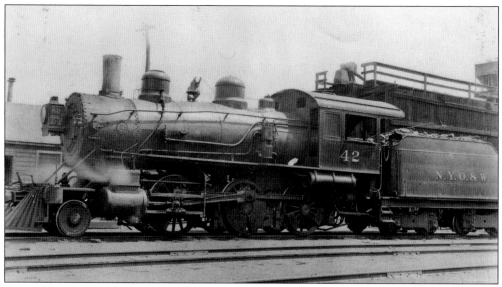

Engine No. 42 was a longtime resident of the Sidney yards. It served its life switching cars and creating the many thousands of trains that came into and out of Sidney. It was also found servicing the sidings of the local customers of the NYO&W. Another distinction in its life was as the last steam engine in service for the railroad as well as the village.

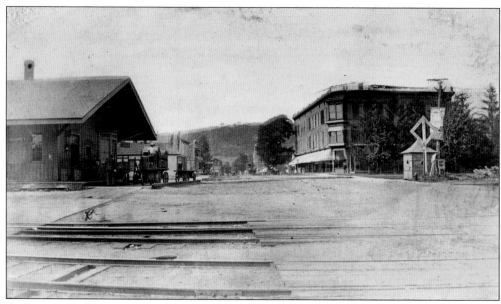

At one time, Sidney's Main Street crossed more than 13 railroad tracks. Each railroad had a crossing guard to protect the public from passing trains. The Delaware and Hudson shack is on the right of the photograph. Behind it is the Sidney Hotel. This railroad station was replaced in 1913.

In the Brooklyn neighborhood of Sidney, the New York Ontario and Western railroad, more commonly known as the O&W, had a small four-stall roundhouse for maintaining its steam engines. Unfortunately it fell victim to fire and was destroyed. An even smaller and simpler one-stall engine house was constructed to replace the four-stall roundhouse.

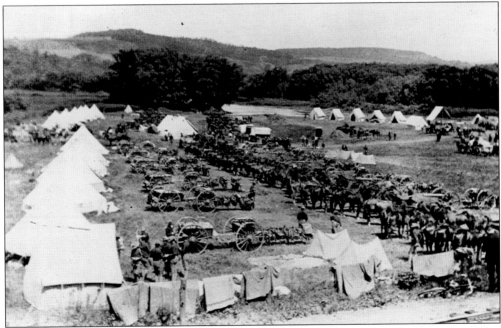

A special train rolled into Sidney in April 1917, bringing about 100 men from Company "D" of the 71st regiment. They had orders to guard all railway bridges on the O&W between Franklin Station and Galena, and on the D&H from Sidney to Cobleskill. Their presence in Sidney promoted patriotic spirit through bugle calls and marches. The troops left in July 1917, when guard duty was passed to the county sheriff.

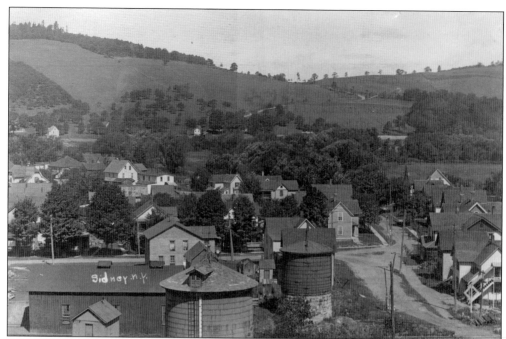

From this vantage point, it is apparent that Sidney was once an active railroad community. Early in the 20th century, Prospect Hill offered an excellent bird's-eye view of the village with few trees blocking the sight. Cartwright Avenue runs parallel to the farthest track. In both photographs, Main Street is to the left. The New York Ontario and Western Railroad comprises most of the tracks pictured and is the closest to the hill. The farther tracks are part of the Delaware and Hudson line. The photograph of Sidney Flour was taken on the right of these views looking towards the left. In the distance, notice how scarce Mount Moses was of trees as well as the farm fields on the outlying hills. (Above photograph courtesy of Evy Avery.)

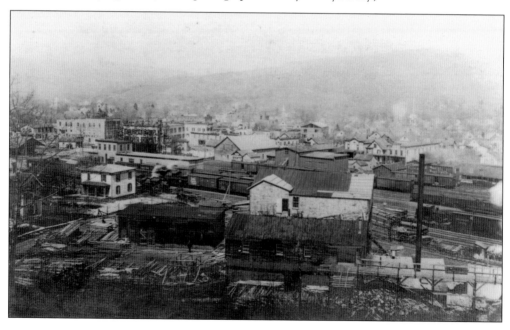

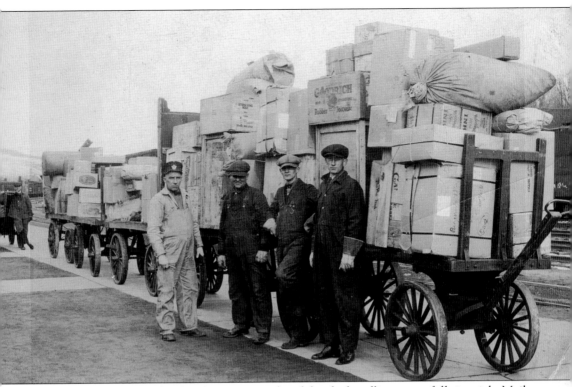

During the peak years of railroad activity, mail and freight handling was a full-time job. Mail sacks and freight were loaded onto hand trucks and pulled into the freight house, where it was sorted and delivered. This photograph identifies four employees of the American Railway Express Company with a string of freight-laden wagons. They are, from left to right, Larry Sisson, Earl Brooks, Duncan Sager, and Bill Empet. (Courtesy of Graydon Ballard.)

Imagine a nice, quiet, and sunny Sunday ride down the road to and from Sidney and it is easy to see how the village became a popular place to live and raise a family. This photograph exemplifies the current Route 7's path through the farmland of the surrounding area.

This view looks towards the village of Unadilla with Bainbridge behind the photographer and Sidney to the right. A covered bridge, and later an iron bridge, took the traveler over the Susquehanna River on this route until 1936. The steep slope of the terrain down to the river can be seen here.

Sidney has the unique distinction of having one of the oldest continuously operated airports in the country. A landing field was established in 1928 on the M. C. Johnston plateau and dedicated in August 1929. Lt. Jimmy Doolittle is reputed to have been one of the first pilots to land there. The glider hangar was constructed in 1930. By 1935, it was deemed necessary to enlarge the hangar capacity. Under the Works Progress Administration, or WPA, the 60-by-100-foot building pictured here was completed in the spring of 1937 and could house up to six planes and a repair shop. The Scintilla-Bendix Corporation hangar served until the present facility across the road was completed in the mid-1970s.

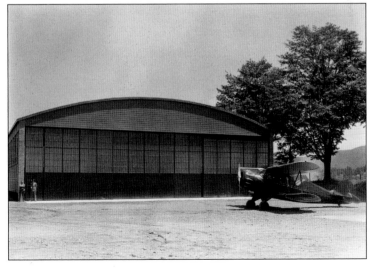

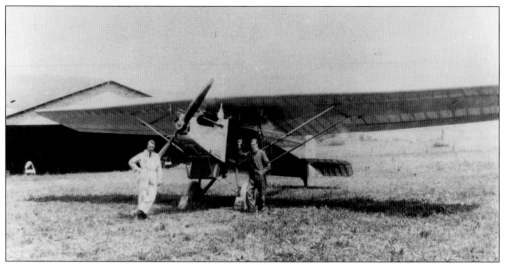

Joe Bennett, pictured with Mike Thurston and their monoplane, spent his boyhood days in Sidney. He moved to Miami, Florida, where he made a specialty of airplane passenger service. He returned to Sidney in 1920 and flew several local citizens for 15-minute flights, taking off from a large lot on the Aitkin Farm between East Guilford and Mount Upton.

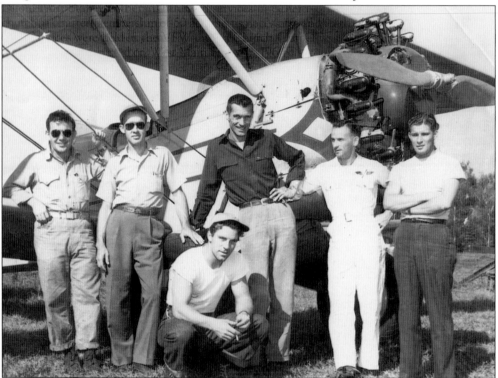

Bob Felske was a pioneer flyer in the Susquehanna Valley who, at age 20, was one of the nation's youngest qualified pilots. Felske and Clifford Pratt owned and operated the Pratt and Felske Flying Service from 1940 to 1955, featuring charter flights and pilot training. Both men were C.A.A. certified commercial pilots and flight instructors. During this period they soloed over 500 students from the old Sidney Municipal Airport.

Eighteen airplanes used the Sidney Airport in April 1942. Planes owned locally were those of P. P. Dower, Ralph Barnard, Larry Nelson, Scintilla Magneto, Cala Flying Club, and Clifford Pratt. Pictured here is the airplane belonging to the Scintilla Magneto Division of Bendix Aviation Corporation, with pilot Ralph Barnard.

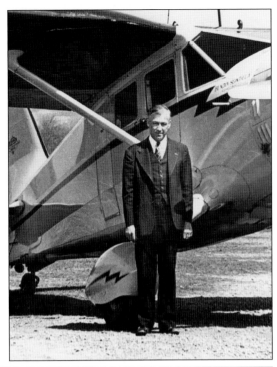

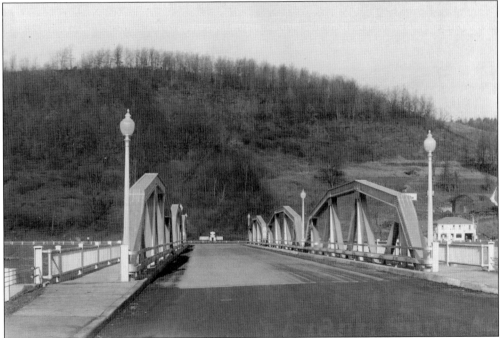

The Main Street bridge opened in 1936, built to create a straight line to the commerce area. The former route brought travelers into a residential area. To connect Main Street with the bridge, a portion of Pioneer Cemetery had to be moved. Graves were either relocated within the cemetery or moved to Prospect Hill Cemetery. With only minor modifications, this bridge is still functioning today.

Interstate 88, or I-88, was added to the Interstate Highway System on December 13, 1968. Construction began soon afterward and was completed in the town of Sidney by the end of the 1970s. What began as a scar on the beautiful landscape has evolved into another transportation mode bringing greater numbers of people and commerce to Sidney. While it may not be true in the present day, Sidney has historically had more jobs than people, and the interstate has been able to feed the workers into the village. Much of the village's historical essence has been preserved, because the highway was built on the hillside away from the village.

Eight

DISASTER STRIKES SIDNEY

The village of Sidney has had its share of disasters, both natural and man-made. Flooding, fires, and transportation-related accidents of varying degrees plague the history of the village.

Any riverside settlement is prone to flooding, and Sidney has been no exception. Such areas experience springtime overflows, enriching the soil for crops; however, the Susquehanna River and its surrounding tributaries have caused watery destruction numerous times. Major flooding was documented in 1905, 1913, 1935, and 1936. The 1960s and 1970s also saw high waters that caused street and basement problems, but the worst flooding on record was in June 2006, with major structural damage that the village may never completely recover from.

Structure fires, especially in the late 18th and early 19th centuries, constantly threatened homes and businesses. From the Mitchell House in 1883, the Glass Works in 1900, the Hotel Sidney and the Novelty works in 1918, and into the 21st century, the village witnessed the loss of over 20 businesses. Only two of the eight hotels in Sidney escaped destruction by fire, including the DeCumber, which narrowly survived an arson attempt in the late 1990s.

At the height of the railroad era in the early 20th century, Sidney boasted 32 passenger and over 70 freight trains daily, with the usual derailments. There were several serious wrecks during the busy years, including a multiple-car derailment in January 1909 in the south yard that resulted in the death of engineer Alvin Sampson. There was a lull until October 1922, when the O&W and the D&H had a head-on collision near the Union Street crossing. Gradually railroading withdrew from Sidney, and the last major derailments occurred in the 1960s near the present-day Sidney Plaza parking lot and in 1987 near MeadWestvaco.

While Sidney continues to experience record-breaking disasters to this day, the village can do nothing but hope that past misfortunes better prepare people for any future problems that come to town. The following images are the efforts of those who realized the importance of historical documentation once the chaos was over.

—*Graydon Ballard*

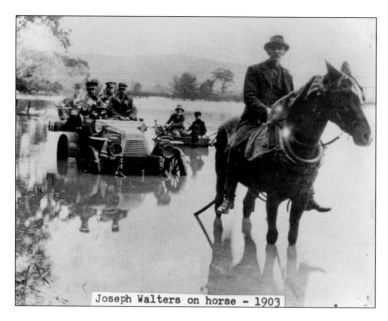

Joseph Walters on horse - 1903

This 1903 picture shows a Columbia automobile, driven by Al Duffy, towed to higher ground by Joseph Walters near the Susquehanna River on present-day Route 7. The car was one of several engaged in an endurance run from New York City to Pittsburgh, passing Sidney just in time to be caught in a flash flood. Walters towed 13 cars out of the mud while others supplied added "horsepower."

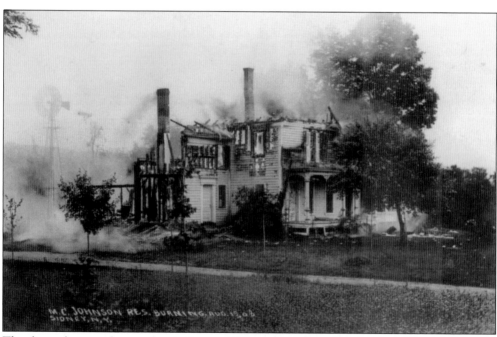

The above photograph was taken in August 1908, as the walls and roof of the Milton C. Johnston home were collapsing. The house and barn on lower River Street was the home of one of the direct descendents of Sidney's founding family. Rev. William Johnston founded the area originally known as Sidney Plains in 1772. (Courtesy of Graydon Ballard.)

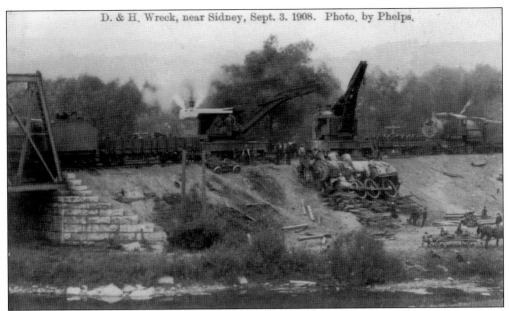

The D&H mail train No. 2 wrecked at 11:25 a.m. on September 3, 1908, about a mile north of the Sidney station near the river bridge. Engineer A. D. Dimmick and fireman George Prindle plunged over the embankment followed by the express, baggage, and two coach cars. Fireman Prindle and E. K. Hitchcock, the express man, were the most seriously injured. (Courtesy of Graydon Ballard.)

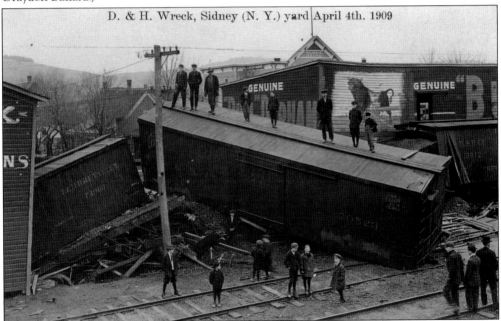

At approximately 10:30 on the morning of April 4, 1909, D&H engineer Robinson and his crew were switching cars in the yards off Cartwright Avenue. As with many derailments, human error came into play and the cars ran a switch, plowing into others on the siding and pushing them into J. C. Merrick's Hide, Skins, and Fur building. Being a Sunday, the building was unoccupied, but suffered considerable damage. (Courtesy of Graydon Ballard.)

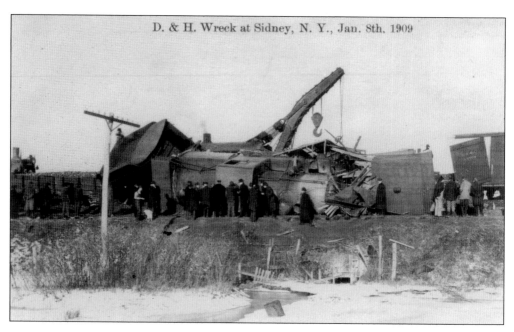

D. & H. Wreck at Sidney, N. Y., Jan. 8th, 1909

The cause of this wreck on January 8, 1909, was something of a mystery. The D&H "fast freight," with engineer Elvin Sampson supposedly at the controls, never slowed upon entering the Sidney yard. The automatic signals were working, but even exploded torpedoes and the frantic flagman were ignored. The engine crashed into the rear of another train standing near the Carriage Works. The crew jumped to safety, but Sampson's body was crushed under the engine. The fireman escaped with minor injuries. No mention was made of the conductor. There was speculation that engineer Sampson may have struck his head on the bridge just south of the yard and was unconscious or dead at the time of the crash. The locomotive and 17 coal and freight cars were destroyed. (Courtesy of Graydon Ballard.)

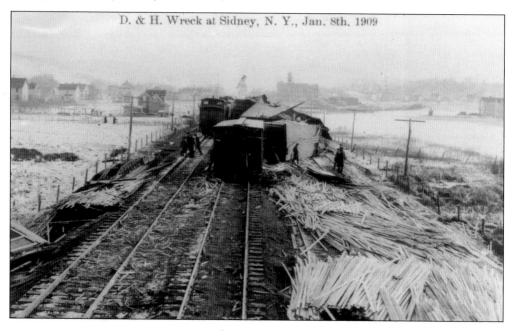

D. & H. Wreck at Sidney, N. Y., Jan. 8th, 1909

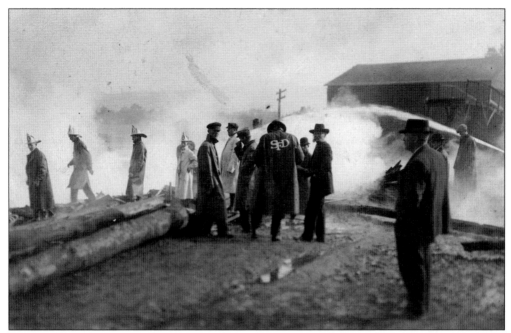

On May 26, 1912, at 4:00 in the morning, there was a fire at the Sidney Mill and Lumber Company. The mill's three-story building, powerhouse, and most of the lumber stock were destroyed in the blaze. Arthur Wood, manager of the mill, did not rebuild in Sidney. (Courtesy of Graydon Ballard.)

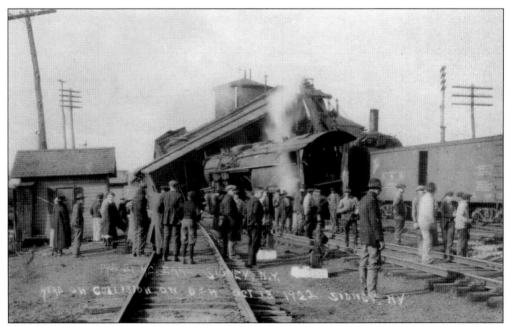

One of the most spectacular wrecks occurred just before dawn on October 18, 1922. Two D&H engines collided near the switch tower on the Union Street crossing, killing one engineer and destroying both engines and six freight cars. It was believed the deceased engineer, William Toal, was asleep and failed to obey the stop signal. (Courtesy of Graydon Ballard.)

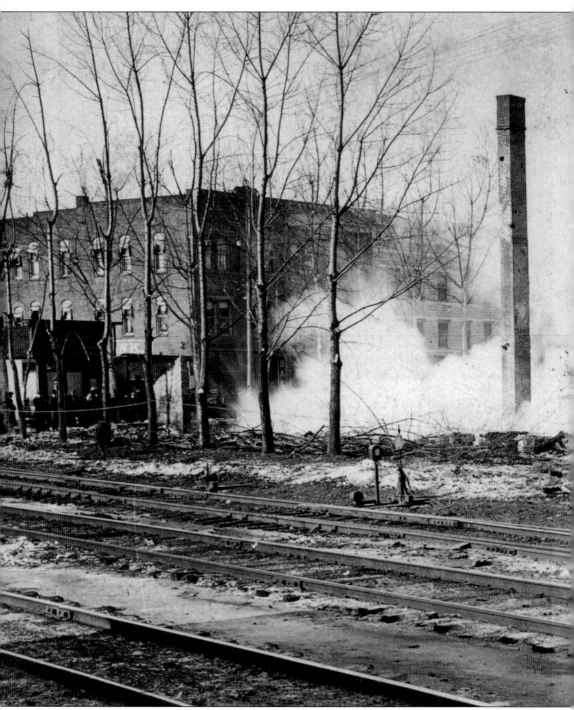

One cold night in January 1918, Hotel Sidney proprietor William Brown made his customary check of the basement steam furnace before going home. Upon opening the door, he was met with a blast of smoke and flames. Rushing back upstairs, he awoke guests, who fled barefoot in their nightclothes. All escaped safely, but within an hour, all that remained of the 60-room hotel was the 85-foot chimney. A windless night, rooftop snow, and wet carpets and blankets hung

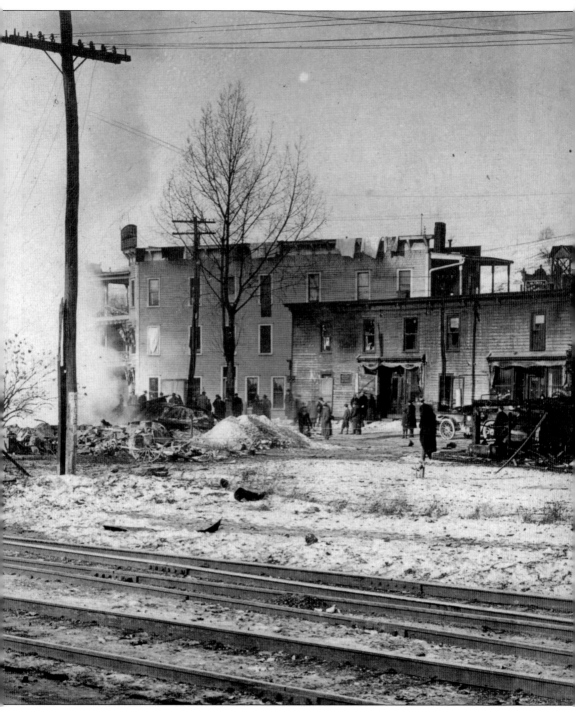

on the nearby DeCumber Hotel were credited with saving nearby buildings. The flames could be seen for miles, with heat that cracked windows close to the blaze. When the roof and walls collapsed, a tower of flame reached a height of 150 feet. Homes on Prospect Hill were showered with burning embers. Fortunately an annex building was the only other structure destroyed. (Courtesy of Graydon Ballard.)

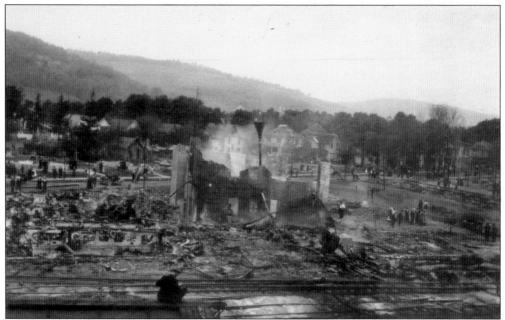

At 5:40 p.m. on May 25, 1918, the night watchman at the Sidney Novelty Company on the corner of Union and Division Streets sounded the alarm for what would be Sidney's most disastrous fire. With a strong south wind fanning the flames, the whole factory was engulfed within minutes. Soon the wind changed to the northwest, driving flames to the nearby Siver Lumber Yard and destroying a row of houses on Division Street. Over three hours, a total of 35 structures were lost, and the Main Street business district was threatened. At about 8:45 p.m., the village was spared when the wind suddenly died and rain poured down. It was reported that, during the height of the fire, live embers were blown as far as East Guilford and the ashes to Mount Upton. Amazingly there were no lives lost and few, minor injuries.

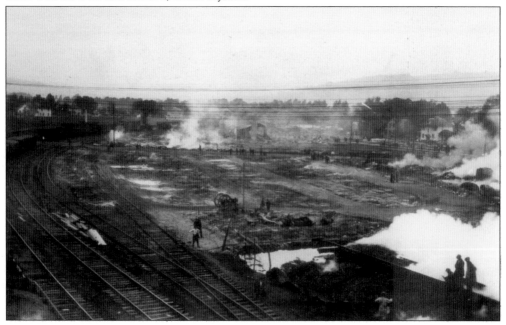

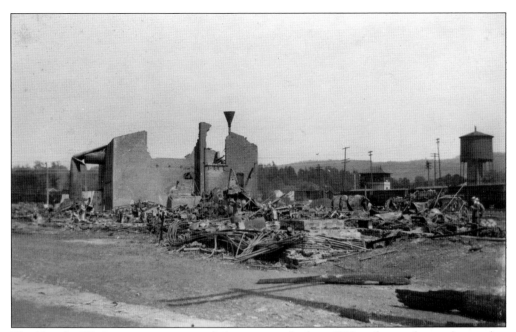

The Novelty Works, as it was commonly known, was built in 1890 and manufactured a number of wooden items such as children's sleds, blackboards, chairs, and other furniture items. It had survived a warehouse fire in January 1903 and bankruptcy in 1914. After the 1918 fire, the business was moved to Norwich. (Novelty Works photographs courtesy of Graydon Ballard.)

The piles of snow on Main Street from this 1925 snowstorm were small in comparison to blizzards Sidney experienced. The "Great Blizzard of 1888" occurred in March. Three feet of snow and fierce winds combined to create drifts that reached up to second-story windows. The "Blizzard of 1993" also happened in March, when almost 2 feet of snow shut down the town.

Unusually high water levels of the nearby Susquehanna River from rainstorms or spring thaws often cause severe flooding in Sidney. The severity of a 1975 flood is evident in this photograph of Amphenol Corporation's parking lot. The construction of Interstate 88 and NYS Route 8 seemed to add to the problem of floodwaters in this area.

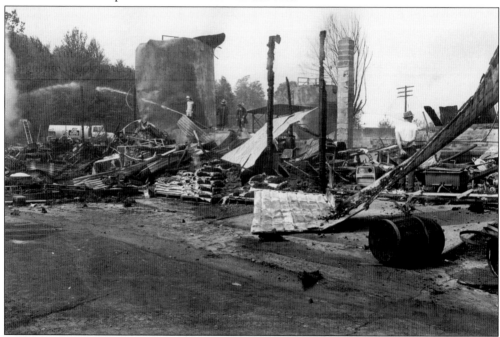

Buildings on Cartwright Avenue were destroyed when three oil storage tanks belonging to James Mirabito and Sons Inc. ignited in 1984. The danger of an explosion forced the evacuation of more than 250 people. At 2:45 a.m., a roll of thunder followed by a huge fireball over 400 feet high signaled the collapse of one of the tanks. K&D Vending and Yahner's Hardware were two businesses completely wiped out.

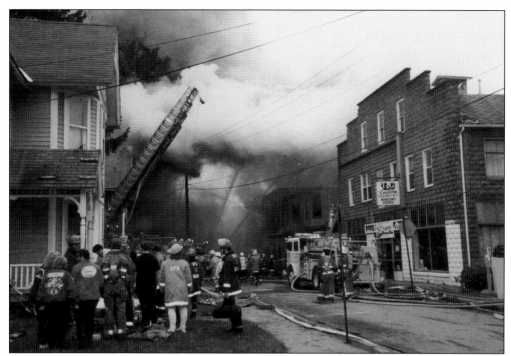

Headlines read, "Sidney Fire Leaves 50 Homeless" on May 20, 1994, after a huge blaze destroyed two apartment buildings and over 250 firemen and 24 fire departments fought to control the damage. The explosion of two propane tanks spread flames from 13–17 Smith Street across an alley to a three-story apartment building. Tenants were evacuated with the aid of seven local heroes. Both buildings were a total loss and were demolished.

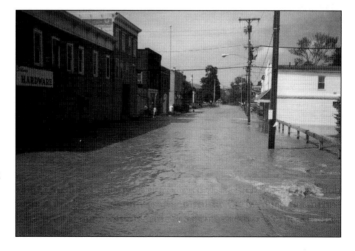

Tuesday, June 27, 2006, was a day that many current Sidney residents will never forget. June had already seen 11 inches of rain and that day added another 3.6 inches to the already saturated ground, rivers, and streams. The added rainfall caused rivers and creeks to jump their banks, running through streets and causing massive devastation in Sidney. It proved to be the largest flood in the area's history.

www.arcadiapublishing.com

Discover books about the town where you grew up, the cities where your friends and families live, the town where your parents met, or even that retirement spot you've been dreaming about. Our Web site provides history lovers with exclusive deals, advanced notification about new titles, e-mail alerts of author events, and much more.

Arcadia Publishing, the leading local history publisher in the United States, is committed to making history accessible and meaningful through publishing books that celebrate and preserve the heritage of America's people and places. Consistent with our mission to preserve history on a local level, this book was printed in South Carolina on American-made paper and manufactured entirely in the United States.

This book carries the accredited Forest Stewardship Council (FSC) label and is printed on 100 percent FSC-certified paper. Products carrying the FSC label are independently certified to assure consumers that they come from forests that are managed to meet the social, economic, and ecological needs of present and future generations.

FSC
Mixed Sources
Product group from well-managed
forests and other controlled sources

Cert no. SW-COC-001530
www.fsc.org
© 1996 Forest Stewardship Council

Find Your Place in History.